How to Price Crafts and Things You Make to Sell

Formulas and Strategies for Arriving at Profitable Craft Prices for Selling Online or Off, Wholesale or Retail

Revised and Updated Edition of:
The Basic Guide to Pricing Your Craftwork

by James Dillehay

More books by this author:
Sell Your Crafts Online
Sell Your Crafts on Ebay
Directory of Grants for Crafts
The Basic Guide to Selling Arts and Crafts
Overcoming the 7 Devils That Ruin Success
Your Guide to Ebook Publishing Success
Weaving Profits

Books Co-authored:
Guerrilla Marketing on the Front Lines
The Best of Guerrilla Marketing
Guerrilla Multilevel Marketing

Published by:
Warm Snow Publishers
P.O. Box 75
Torreon, NM 87061
www.Craftmarketer.com

ISBN-10: 097106847X
ISBN-13: 978-0-9710684-7-6

Printed and bound in the United States of America

One of my earliest exposures to the challenge of pricing was a story my father told me. He grew up in a farming community in East Texas and later went on to build a successful business in retail. As a youth at the local outdoor market, he overheard a country farmer say to another about a vendor selling his wares, "What he's a askin' and what he's a gittin' are two different things."

Contents

Introduction

One of the most often asked questions from those who make things to sell is *"How should I price my crafts?"* Whether you have been selling your handmade products for some time, or you are just starting, this handbook will help you answer that question in ways that increase your sales and your profits.

How to Price Crafts and Things You Make to Sell is a revised and updated edition of an earlier book I wrote called, *The Basic Guide to Pricing Your Craftwork*. This new edition covers online and new offline pricing strategies to help you be more competitive in the markets in which you sell.

You may be asking yourself, *why do I need a book; can't I just use a simple formula to price my items?* The problem is that no single formula (like multiply your costs times four) really pays off in all situations. In these pages, you are going to discover why applying a one-price-fits-all formula leaves money on the table, time and again. Don't worry, you will get formulas, examples and instructions on how to price for both selling retail and wholesale. But the approach presented here helps you incorporate input uniquely related to your craft making which will give you more profitable results than *one size fits all* pricing.

Beyond pricing formulas, this guide teaches pricing strategies. Strategizing is when you work *on* your business, instead of *in* your business. No matter what you make and sell, the shortest road to being more profitable is taking time out from production to brainstorm how to run your business more profitably. Think

of your business itself as a product and you will craft it with as much attention and care as you would one of your pieces.

This book will show you ways to increase your sales and give your profits a boost through better pricing methods. It will also show you how to know if you are really making a profit, how to keep records, how to cut your material costs, and how to manage your time and workspace to get the most out of what you have to work with.

You will also pick up several tax advantages from operating a home based craft business and you'll learn ways to boost your daily available cash on hand.

If all this sounds good to you, you will probably find yourself wanting to mark up the book with notes. Do it. My favorite how-to books have my yellow highlighted sections throughout. When I want inspiration, I go back and skim the parts I've marked up.

You may have started your craft business purely from inspiration and probably not a lot of business training. This book can give you a vision and model of what makes a business profitable.

Unfortunately, many crafters do not charge enough for their work. I certainly didn't when I began selling. This tendency may come from not seeing the value of our work to others. But there are more and more shoppers who buy handmade because they like to support artists economically. Many of these shoppers are willing to pay a little more for owning items made by hand.

The strategies and formulas here can guide you to start tweaking your marketing, packaging and prices. You'll also want to come back and look at your prices over time at regular intervals. The prices people are willing to pay go up; plus local and regional economies change. Even if you use every idea in

these pages starting today, staying profitable means continual testing and measuring.

If you read the book all the way through, you should arrive at an understanding of two fundamentals to profitability: the real cost of every item you make and the highest price buyers are willing to pay—the latter is, by the way, quite possibly the most overlooked element of any craft business owner.

Strategic pricing includes learning which markets attract buyers accustomed to paying higher dollars and how to position your products there. It's also about increasing the perceived value customers place on your items so you can raise your prices and sell more of them without encountering buyer resistance.

By now, I hope you are getting a sense of where we are going with this approach and feeling excited about the possibilities. My guess is that you invested in this book because your prices, and therefore your entire business, probably needs a tune-up.

After applying the suggestions here, you'll begin to gain confidence of knowing where your business stands at any given moment in time and how you can use your knowledge to achieve both your personal and business goals. I am teaching you the model to higher profits, but you have to apply the efforts to realize the gains.

Feeling like you're going it alone is tough. Consider joining www.craftsu.com, a social network of artists and craftspersons for buying and selling their work.

To your success,
James Dillehay
www.Craftmarketer.com

Chapter 1
What We Value

"If you really do put a small value upon yourself, rest assured that the world will not raise your price." ~ Anonymous

We are all motivated by what we value. The more we connect with what's important to us on a deep level, the more motivated we become in our life and in business. A strong motivation can accomplish miracles. You read stories of those who have achieved much in the face of adversity. If we want to achieve more, we have to be inspired. The path to getting what we want lies in strengthening the links between what we value most and our goals. The closer these two become interwoven, the more energy we have to devote to our tasks.

So what does motivation and value have to do with pricing? As new craft sellers, we tend to under value our work and consequently under price our products. This chapter aims to help you get in touch with a heightened sense of the value of what you do so that you can move into a place of confidence when you to sell your work.

A good place to start is to identify your goals and write them down. You want more personal freedom. You want to work when, where and how you choose. You desire more income. You want to express yourself creatively. What would all of this look like in terms of your daily life?

Having an inspired vision can keep you actively involved in your business despite longer hours, often less pay, and unex-

pected challenges. When you connect inwardly with the work you do, you don't feel obstacles as drudgery, you just move forward through them, because you are doing exactly what you want.

An excellent tool for motivating yourself and upgrading the value you set on your business is to create a dream book. To build your dream book, collect photographs from magazines that portray those things you want in your life. Paste these photos on the pages of your book, kind of like scrapbooking memories except you are building a collection of your ideal future.

For instance, you might want a new car. Look through a magazine with pictures of the exact car you want. Cut it out and paste it into your book. You could also do this with images of far-off places you wish to travel to. Find photos of families having fun together. Whatever you want in life, find a picture and place in your book.

By going through your dream book frequently, you remind yourself of where you want to be in life. Your subconscious will begin to help you act in ways which will bring your dreams into reality.

"When you undervalue who you are, the world will undervalue what you do and vice versa." ~ Suze Orman

Every day, spend five or ten minutes visualizing having already achieved your own goals. What does it feel like to own your life, to have money to do what you want, to take off work to devote more time to your family.

Strengthen this mental image of yourself as already a success; build it in the center stage of your mind's eye. After a few days of doing this exercise, your subconscious will begin

directing you to do all the little things necessary to make those images come about.

If you have needs and values that motivate you, be assured that your customers have values and are motivated by them. Your most successful marketing messages will educate customers on how your products will fulfill their needs.

What Motivates People

There is a psychology to shopping. When you understand why people buy and why they will pay more when you have sent the right signals, it pays off with you getting top dollar for your products.

Abraham Maslow's theory of the hierarchy of human needs says that everyone is motivated by a set of commonly experienced needs. In summary, those basic human needs are freedom from fear, good health, emotional comfort, more money, being popular, convenience, entertainment, someone to love, time, sexual fulfillment, pride, physical comfort, warmth, attractiveness, prestige, and so on.

Evaluate your products against the list and see if they help meet any of the basic needs. A handmade quilt or bedspread might keep you warm, bring value as an heirloom, be worthy of pride, and convenient to use.

The marketing messages that win sales then are those that speak to one or more of people's needs. Seen in this light, the pricing question then becomes one of determining how much value people place on getting their needs met.

I noticed at craft shows occasionally a customer asked me about how long it took to make or what materials were in a piece they were admiring. Most of the time, however, the person wanted and needed to know how the piece looked on them in

front of a mirror. Their second concern was how much it cost. If my price was not out of line with what the average market price was for that type of product, I often made a sale.

> *"This may seem simple, but you need to give customers what they want, not what you think they want. And, if you do this, people will keep coming back." ~ John Ilhan*

Advertisers and marketing experts make use of human motivational triggers all the time when designing promotional material. The idea is to move a person to buy a product by stimulating one or more basic need. However, it's important to note that even though people have a wide range of needs, it is really what they want that makes them act. When you become aware that you are in fact providing the fulfillment of what people want, you will experience a brighter dawn in all of your marketing results. Therefore, let your packaging and promotional material remind your customers of benefits they will receive upon becoming the proud owner of one of your pieces.

This theory of meeting the customer's desires requires us to adopt *"you"* thinking and get out of *"me"* thinking. A simple reminder is that customers buy products based on their wants and needs, not yours. When all other circumstances are equal, customer-benefit-oriented selling will almost always give you the competitive edge.

When I was first learning to weave, I wove a sampler scarf using many different patterns, yarns, and colors my teacher gave me to experiment with. It was a great feeling when only two weeks after beginning (this same piece would now take me two hours) I was ready to cut the finished piece off the loom. As it

happened, a friend walked by soon afterward and saw it draped over my loom. It was my first commercial display. She saw the scarf, fell in love with it, and said she wanted to buy it.

Wow, was I excited! The only problem was I had no idea what to charge. After all, she was a friend and I was *only* a beginner. Meekly, I said *"How about $20."* She said okay and that was my first sale. If I had known to check stores and craft fairs, I would have learned that scarves like mine were selling for $60 and up.

That spur of the moment pricing decision wasn't based on appropriate value. I didn't stop to figure how many hours I had worked or the cost of the materials or what shoppers where accustomed to paying. Of course, I knew I was in the learning phase and that my labor time would decrease when I got more experience. I learned to check around before quoting prices.

"We can tell our values by looking at our checkbook stubs." ~ Gloria Steinem

Local Economic Data

You will be able to get higher prices for your work in places where the economy is good or growing. On the other hand, if people are out of work, attempting to sell to them will be a real challenge. You have to go where the money is.

If your local area is financially depressed, this may mean traveling to do craft shows in other states where jobs and disposable income are plentiful. If doing shows isn't practical, consider getting your work in shops, galleries, and craft malls in economic hot spots around the country. Typically this means getting informed of where tourists are flocking so you can follow the money trail.

One way of getting a good picture of economies in states or areas you are considering selling to is by contacting your local SBA (Small Business Administration) office or SBDC (Small Business Development Center.) To locate an SBDC near you, see http://www.asbdc-us.org/About_Us/SBDCs.html

Small Business Profiles at http://archive.sba.gov/advo/research/profiles/ provides an overview of each state's economy such as new firms, business dissolutions, small business income, exports, and detailed data on the economy not available elsewhere. For example, you can learn whether a state's unemployment rate has risen or fallen compared to the national average. This information indicates if a state is experiencing economic growth.

In this chapter, we've looked at how to come to value your work more and understand how your prospective customers are motivated. In the next chapter, you are going to discover tactics that help increase the perceived value of your items so that you can confidently raise your prices and boost your profits.

Chapter 2
How to Raise Prices Without Raising Eyebrows

"Between two products equal in price, function and quality, the better looking will out sell the other." ~ Raymond Loewy

Perceived value is the worth a shopper places on an item when considering a purchase. Newcomers in business almost always underprice their craft products thinking they will attract more buyers. In the handmade marketplace, lowering the price more often lowers the perceived value. Raising the perceived value, however, lets you increase your prices and boosts your sales.

Price is not typically the top buying criteria in the hand-made marketplace. The exception might be selling on Etsy in a category where there are many competitors, like jewelry. What is true more often is that sales are driven by the quality of your work, how-when-where you display it, packaging, and other promotional activities.

In this chapter, you will find fifteen ways to influence shoppers both online and off by raising the worth of what they are getting for their money, allowing you to raise your prices without raising shoppers' eyebrows.
- Tell them it's handmade
- Produce quality work
- Bring back that loving feeling

- Call attention to luxurious materials
- Be earthly friendly
- Take stunning photos
- Display your artist's statement
- Include benefits in your descriptions
- Use eye candy packaging
- Sell sets
- Build inviting displays at craft fairs
- Personalize the product
- Brand yourself
- Appeal to collectors
- Instill confidence

Tell Them It's Handmade

The fact that you make something by hand should be highlighted at the top of your marketing messages and is probably your number one way to increase perceived value. When writing my book *Sell Your Crafts Online*, I found that thousands of people search Google every day using phrases related to handmade gifts. In January of 2011, $33.5 million of goods were sold on Etsy, up around 60 percent over the previous year. Etsy's increasing growth rate reflects the demand of consumers for handmade products.

Produce Quality Work

Objects of beauty crafted by hand communicate a feeling, an essence that is never found in mass produced items. Quality work, especially when viewed on display, markets itself and speaks of value beyond words.

When an artist's intention is pure, the works made by their own hand may become endowed with a special and dis-

cernable quality known as baraka. Baraka, although a familiar term throughout Asia and the Middle East, is hardly known in the West. There is no English equivalent for this word, yet you can see and feel it when observing works of the highest quality.

> *"If you don't do it with excellence, don't do it at all! Because if it's not excellent, it won't be profitable or fun, and if you're not in business for fun or profit, what the hell are you doing there?"*
> *~ Robert Townsend*

Bring Back That Loving Feeling

You may have grown so accustomed to your work that you don't see your pieces with the same adoration you once had. But when you are selling face-to-face, shoppers watch what you do, so look at and handle your items with adoration while you are talking with folks about your work.

Lovingly touch, hold or pick up your handmade item to show prospective customers; handling it as if it were made of the most precious and rare materials. The way you handle your item is a subtle yet powerful communication to would be buyers.

A take off on this approach is to not pick up an item at all but simply brush your fingers along its surface as if you were touching your lover.

> *"If we actually love what we're doing and we go and do what we love, and every day we get up because we're really happy to get up and go and do what we do, you can't actually do that without expression, and art forms part of that mix of expression that makes the whole package of life so enjoyable to be in."* ~ *Kerry Stokes*

Call Attention to Luxurious Materials

To up an item's value in the eyes of the shopper, emphasize the exclusiveness and luxuriousness of it's contents in your product descriptions on your hangtags, websites, brochures and other marketing materials.

Jewelers can do this by accenting the quality of the gold or silver in their pieces with phrases like *solid gold* or *sterling silver*. A handbag maker could emphasize the *100% leather* exterior. If you use materials that are rare and hard to find, be sure to mention that in your marketing.

I wove a series of shawls with cotton and mohair yarns, pricing them at $65 each. For several months, they didn't sell. I replaced the hangtags with new ones drawing more attention to the fact that the pieces contained "pure Angora mohair" and then I raised the price to $85. All of these pieces sold in my next show and continued selling well with the new tags. This inspired me to make more pieces using expensive materials which also sold at higher prices.

> *"Luxury goods are the only area in which it is*
> *possible to make luxury margins."*
> ~ *Bernard Arnault*

Be Earth Friendly

If you use environmentally friendly materials, use words in your product signage and descriptions to remind shoppers that your products are eco-friendly, sustainable, green or from recycled materials (of course, only if any of these are true.) For example, you might make dinosaur sculptures from recycled tin thrown out from construction sites. Or you might use lead-free solder or paints.

Consumers are on the lookout for the environmental impact of the materials in the products they buy. Shoppers are willing to pay more to go green. Just look at the success of *Whole Foods*, for example.

One of my clients recycles inner tubes from eighteen wheelers into fashionable handbags. We built an entire publicity campaign around the angle of the recycled materials. They got tons of news media calling to interview them. We even raised their prices and sales went up, showing that shoppers are willing to pay more for products shown to help the environment.

Take Stunning Photos

Using classy looking images will make or break your online listings at Etsy, eBay or your own website. Even in your offline marketing materials, the photos you use come across immediately as either memorable or forgettable in shoppers' eyes.

There are many ways to photograph your crafts to enhance value. One method is to include shots taken from different viewpoints so shoppers get a sense of depth. Take photos in daylight or under Halogen lights (whiter light) or color-balanced lighting Use a plain background to make your item stand out, but don't use a white background as it tends to create too much contrast. Use a drape or a blank wall for your backdrop.

If you are on a do-it-yourself kick or you like photography or just can't afford to hire a photographer, there are numerous tips and advice online for taking great photos. See the list of resources at: http://www.handmadeology.com/big-list-of-product-photography-tips/. For creating sales-generating images specific to art and craft items, see the book, *Photographing Arts, Crafts & Collectibles* by Steve Meltzer.

Proudly Display Your Artist's Statement

Successful craft artisans include their story on their promotional material, websites, hang tags, and prominently on their booth displays at shows. Stories add a human element while enhancing the perception of value. Write about how you got into your art or craft and where you work. Tell what went on behind the scenes in order to produce an item. Describe your personal journey or evolution with your skill as an artisan.

Building on your artist's statement, you can increase the worth of a handmade product with a *Certificate of Authenticity* signed by the artist.

Mention any awards or relevant educational achievements in your story. Are you a second or third generation craft artist? If so, that's interesting to shoppers.

All of your promotional material, including your sales receipts, brochures, flyers, postcards, and web pages should include the personal touch of your artist's statement that allows the buyer to connect with you as a real live working artist. I came across some good examples at: http://www.artstudy.org/art-and-design-careers/sample-artist-statement.php. For more artist statements, Google the phrase: "artist statement examples."

"As a small businessperson, you have no greater leverage than the truth."
~ Paul Hawken

Include Benefits In Your Descriptions

When listing your items at online shops like at Etsy, Artfire or Craftsu.com, your descriptive text has to grab the customer's attention, entice them to read more, and then convince them to buy an item that is worth the price you are asking.

Descriptions can enhance value by informing how a product will benefit your customer. As already mentioned, the customer is really shopping for what benefits her, not you. Features are how you measure a product, while benefits speak to the shopper's needs. Earlier, we looked at how to up an item's worth by reminding shoppers of what it's made of. For example, these next three statements speak of features:

> *"This wool and mohair jacket is handmade from all naturally dyed yarn."*

> *"These rag rugs are woven with long lasting, durable materials."*

> *"This rocker is solid oak and handcarved."*

Let's change these statements to emphasize benefits telling the customer what's in it for them, another way to increase appeal via perceived value:

> *"This wool and mohair jacket will keep you warm on those cool nights."*

> *"Your one-of-a-kind rag rug will last you a long time. You'll be able to walk on it comfortably for years."*

> *"This heirloom, handmade rocker will increase in value over time as a collector's dream."*

When adding descriptions to your online listings or printed materials, lead with benefits and follow with features. In my training to become a Certified Guerrilla Marketing Coach, I

learned that a powerful way to stand out in your marketing is to learn the benefits of both yours and your competitors' products, then accent the benefits of your items that the other fellows don't mention.

> *"Many a small thing has been made large by the right kind of advertising."* ~ Mark Twain

If you don't tell customers why your work is better, they may not figure it out on their own. Maybe it's important that you do every single step of the craft by hand or with traditional hand tools. Do you come from a long line of craftworkers in your family? Are you one of the few artisans in a craft that is no longer practiced widely? Is your studio located near a place of historical significance?

Producing craft unlike anyone else's is one of the most enjoyable aspects of making and selling your work. Let your customers know why your work is original.

Use Eye Candy Packaging

Another way of increasing perceived value is to make use of eye candy, that is, elaborate packaging techniques like brilliantly adorned boxes, ribbons, or wrapping. Shoppers often buy the packaging of a product as much as the contents. Packaging your work in eye catching ways helps convey worth and value to shoppers because it:

- Captures attention by focusing the eye on something new
- Makes buyers happier with their purchase
- Sets your products apart from competitors
- Protects your products in transit

- Identifies your brand
- Lists contents
- Instructs on use of the product
- Boosts sales by providing contact information (you might need separate packaging without your contact information for sales to stores as they don't like losing customers to you.)

A popular weaver produces handwoven scarves from hand-dyed silk yarns. He designed a beautiful box with an accompanying booklet explaining the history of his weaving to go along with each scarf. The cost of the scarves before the box was $75. By adding attractive packaging, he increased the retail price to $95. It makes sense to spend an additional $4 to upgrade a product's perceived value through packaging if you could earn an extra $20 in profit. Extra profit isn't the only benefit here. With this weaver's unique packaging and exceptional product, he captured new markets and grew brand name recognition. His boxes were so different and so exquisite, it became apparent to customers his work was also unique and desirable above the competition.

I went looking for examples of great packaging from craft artists and found a huge collection of images at: http://www.flickr.com/search/?q=packaging Granted, there are some junky photos in this collection, but enough good ones to give you plenty of ideas to create your own unique eye candy wrapping.

"I'm not a driven businessman, but a driven artist. I never think about money. Beautiful things make money." ~ Geoffrey Beene

Sell Sets

Selling several items together at a slightly discounted price can be more profitable than focusing on single product sales. A discounted set is a clear savings to shoppers. When you can move more items at one time, you will usually save on *costs of sale* down the road. Every time you make a sale, whether it's at a craft fair, on Etsy, or anywhere else, there is a *cost of sale* involved. For instance, you have to pay booth fees at events, listing and sales fees on Etsy and so on.

Another area where you can save with your online sales is in shipping costs. It's almost always going to be cheaper to ship a bundled set of items than, shipping multiple items one at a time.

Some crafts lend themselves naturally to package deals. Jewelers often put together sets made up of bracelet, earrings, and necklace. Knitters make up hat and glove sets. Soap makers sell baskets with soap, shampoo, moisturizer, and air freshening potpourri. The more related the items are, the easier it will be for the customer to see the value in purchasing a set.

Naming your packaged products helps call attention to how the deal is special. Call the product bundle a collector's set, a gift basket, or holiday set, and give each one a name; something like *The Artisan's Selection* or *Your Name's Gift Set.*

Gift basketing alone can open up a whole new world of gift buying customers both individuals looking for something special and businesses and associations that reward employees with performance bonuses. Real estate brokers sometimes send gift baskets to their clients after closing a deal. Gift baskets also allow you to zero in on specific occasions like Christmas, Easter, graduation, Mother's Day, Valentine's and many others. Check out the list of gift basket ideas at: http://www.giftbaskets.com/gift-basket-ideas.cfm

Build Inviting Displays for Craft Fairs

Your display at a craft show is a form of packaging. Maybe because it's so big, it doesn't look like a package, but everyone that walks by sees it and makes a decision to enter or keep going. The more professional your display, the more confidence shoppers feel toward you and your prices.

Take some time to create an attractive, inviting booth display. Extra lighting focused on a piece puts an item in the spotlight. Any fabric that a product sits on makes an impression. For instance, laying pieces out on a rich velvet fabric creates an image of luxury. Try different materials to see how your crafts look resting on them. Some craft pieces look better against a metal display; some are more attractive next to wood backgrounds.

Get inspiration by researching displays in upscale department stores and note what they do to draw in the eye. Also check out http://www.flickr.com/groups/715724@N24/ for thousands of photos from crafters displaying at shows.

Personalize the Product

Many artisans capitalize on the demand for personalized products with engraving, embroidering, painting, burning, or otherwise applying the customer's name to their recently purchased item, for which you can charge an extra fee.

> *"When you give somebody something with their name engraved on it, they know you didn't just pick it up along the way," says Colonel Littleton whose personalized products are owned by Bill Clinton and Robert Redford. "And a pocket knife with your granddaddy's name engraved on it, now that's something that you'll treasure forever."*

Another form of personalized service consists of taking special orders. I get asked at almost every show if I will make a piece other than what I already have on display using specific colors. I typically add fifteen percent surcharge for special orders, add shipping, and require fifty percent deposit.

Brand Yourself

The better you can brand your art and your name as an artist, the more you can ask for your pieces. Branding is getting people to remember and recognize your name. Everything we've talked about in this chapter so far can contribute toward how memorable you become as an artist.

Making a professional presentation is a priority, but often, brand name artists who've made it big also have a distinct style or theme that seems to run through their work and is instantly recognizable.

Painter, Thomas Kincaid brands himself as "Painter of Light" and has made millions licensing his art onto calendars, posters, books and hundreds of products.

Mary Engelbreit has become known from her range of licensed products that stretches from dinnerware to screensavers, a successful retail store in her hometown, an award-winning magazine, more than 150 book titles published and hundreds of millions of greeting cards sold.

Anne Geddes sells millions of her themed books and calendars showcasing her photos of babies and moms.

Your goal may not include the fame or income levels that these well-known artists have built from their creative work. But you can command higher prices successfully through using branding methods that help boost your image.

"Lots of ambitious work by young artists ends up in a dumpster after its warehouse debut. So an unknown artist's big glass vitrine holding a rotting cow's head covered by maggots and swarms of buzzing flies may be pretty unsellable. Until the artist becomes a star. Then he can sell anything he touches." ~ Charles Saatchi

Appeal to Collectors

Many buyers of handmade craft items are collectors. Shoppers become *collector customers* with less concern for the price you ask as for the value of owning another in a series of your pieces. From your first sale onward, cultivate a mailing list of your customers. Treat them well, because they can bring you business for years through their own purchases and their referrals.

Calling your work a *series* can spark the collector impulse. For instance you could produce a limited edition or numbered series (for which you can ask higher prices) designed in a unique theme such as tigers, or penguins, or rainbows, or dragons. A fiber artist I know names each of her elegant, high priced pieces. She calls one of her $700 coats, *Begonia Dreams*, another is named *Sage Sunsets*.

Attracting collector customers can happen naturally as buyers come to know you and your work. But new customers may need to feel more confident about you. You can boost shopper confidence levels with the following ideas.

Instill Confidence

Here are six things you can do to build trust with customers:

1. Demonstrate your craftsmanship at shows and events. A live demonstration is entertaining, educational and shows shoppers you are a genuine artist.

2. Include customer endorsements and competitive awards you've won on all your marketing materials. It isn't what you say about your items, it's what others say that influences the decision to buy.

3. If it's possible, and this may be a tough one, try to get your item into the hands of and endorsed by a celebrity. Celebrity endorsements really bump up the perceived value because shoppers know that famous people wouldn't associate their name with a bad product.

4. Partner with trusted brand names. Display Mastercard, Visa, American Express and Discover signs because they instill confidence. If you as a merchant accept those credit cards, you are more likely to be a legitimate business. You are tapping into the added confidence that these major brand name services convey.

5. Offer a guarantee. When you list items for sale online, you are up against a ton of competitors. Offering customers a satisfaction or money-back guarantee is a real trust builder that can set you apart from other sellers. When selling at shows and events, the confidence that comes from a guarantee is replaced by your being physically present so you don't really need more.

6. Social proof, for online sellers. One of the most popular ways to provide social proof is including a widget or plugin that displays how many people have *liked* your page on Facebook. To find such widgets and plugins, Google the phrase "widget or plugin to display Facebook likes."

> *"The key to longevity is to keep doing what you do better than anyone else. We work real hard at that. It's about getting your message out to the consumer. It's about getting their trust, but also getting them excited, again and again."*
> ~ Ralph Lauren

In this chapter we looked at the many ways you can confidently mark up your pricing through lifting the perception of your products' worth. When you upgrade the value your customers place on your items, you will see a dramatic improvement in sales and profits.

Remember this checklist of ways to increase perceived value:

____Tell them it's handmade

____Produce quality work

____Bring back that loving feeling

____Call attention to luxurious materials

____Be earthly friendly

____Take stunning photos

____Display your artist's statement

____Include benefits in your descriptions

____Use eye candy packaging

____Sell sets

____Build inviting displays at craft fairs

____Personalize the product

____Brand yourself

____Appeal to collectors

____Instill confidence

I hope this chapter gave you a sense of how much creative control you can exert in boosting the value of your items before you sit down to formulate prices. The next chapter explains the parts of the formula for determining prices for your work whether you are selling retail or wholesale.

Chapter 3
The Pricing Formula

"Price is what you pay. Value is what you get."
~ Warren Buffett

Think of pricing as made up of two parts. The first part is learning how much it costs you to make an item. The second part is determining how much buyers are willing to pay for it. With these two pieces of information, you can calculate a price that satisfies your customer, eases the way to making a sale, and ensures that you earn a profit.

After reading this chapter, you will be able to determine with near certainty what it costs to make your crafts. You will also discover where to look to learn what shoppers will pay for work like yours.

The topics covered in this chapter include:
- Understanding retail and wholesale pricing
- Researching average market prices
- Determining your cost of goods
- Determing your indirect costs or overhead
- Figuring the amount you must recover
- Advanced look at indirect expenses
- Finding your hourly cost of doing business
- How knowledge leads to profits

If you are just starting to make and sell your things, you may not have all the information described in this chapter. Here's a quick fix that gets you going. Research what items like yours

are selling for in the same markets you're in and price your things similarly. Remember though that this approach is only appropriate in your start-up phase. Once you've sold several pieces, you will be in a position to fine tune your prices in a way that accounts for your costs.

Understanding Retail and Wholesale Pricing

You may choose to sell your work in several different kinds of markets like on Etsy or eBay, in gift shops, at home parties, at craft shows, to interior designers, through galleries, or mail order catalogs. In terms of pricing, keep in mind that all of the just mentioned markets fall into one of two categories, retail and wholesale.

The retail price is what you ask for a piece when you are selling direct to the customer. Examples of places you might sell retail include art and craft shows, online through your web site or sites like Etsy, home parties, or from your own studio.

The wholesale price is what you ask for items you sell to someone else who in turn marks up the price and then sells it to their customers. For instance, stores, galleries, and mail order catalogs like Sundance Catalog would all be considered wholesale markets. Stores tend to operate on a model where they price items at twice what they pay for them. Mail order catalogs want better margins and price things at three to four times their cost.

Knowing if you can afford to sell wholesale profitably, can open new markets and bring in more income when other sales channels dip, fade, or dry up. Some crafters begin their business selling retail online or at craft fairs and then open up enough wholesale accounts that they then choose to stay home and work while the stores do the selling. There's no definitive answer to

whether wholesale or retail is a better business model—try all the selling venues to discover what you like and don't like.

Keep in mind that to be profitable selling wholesale, you have to know your production costs as well as your production capacity; in other words, how may items you can actually make within a given time period. Another important challenge with selling wholesale is that store and catalog buyers buy on credit from you—they agree to pay in thirty days. But most won't pay you in thirty days and you may not get paid for ninety days or longer; this is especially true with big department stores like Bloomingdales.

You might discover that after paying booth fees and travel expenses to get to craft fairs, you make the same profit you would if you had sold wholesale to stores. Imagine the difference in your home life if you found you could make just as much money staying home selling wholesale as you did traveling to events twenty or thirty times a year. Wouldn't knowing that be worth a little time spent recording and analyzing your sales and expenses?

It isn't so difficult to sell both to wholesale and retail channels as long as you keep the distinction between your pricing clear. However, if you are going to be selling to stores, you absolutely have to know the minimum or floor price to ask, discussed later in this chapter.

Many craft makers, including me, have met shop buyers who approached them at their booth at a craft fair. The shop buyers will ask whether you sell to stores. They want to know your wholesale prices, payment terms, and when you can deliver. Are you ready with the answers?

Researching Average Market Prices

The average market price for a given product is what most artisans sell similar work for in the same market. This amount tends to be the price the market will bear or the most customers will pay. The average market price is also sometimes referred to as the ceiling price. To find the average market price, survey what is selling where and for how much. This can be an adventure of sorts, going online to browse Etsy, Artfire or eBay or physically visiting events and stores to scope out the field. However you go about it, you need to do some kind of market survey.

To make the job go a little faster, here are seven online venues to survey prices for handmade items:

• www.etsy.com/treasury. Treasury listings indicate popularity so you can use items you find here as sample pieces to estimate what you can sell your items for.

• www.craftcount.com. On craftcount.com, you can view the top sellers on Etsy by category. Clicking on the seller's link brings up their store. It's a safe bet that they have found good price points because of their high sales volume.

• www.ebay.com. On the left side of the page, under "categories", select "crafts", then look for and click on "handcrafted & finished pieces." Then look for "preferences" and choose "completed listings." The last time I did this search, I got over 19,000 listings. On the right side of the results page are completed auction listings of products. Sort the listings by choosing "price: highest first." Look for: (1) products that are actually selling, (2) number of bids—this shows whether people are anxious to buy these crafts, (3) price—shows the highest bid or how much people were willing to pay.

• www.sundancecatalog.com. Sundance Catalog is among the most popular mail order catalogs featuring handmade items. They mail copies to millions of shoppers. Unfortunately, for the craft artist, catalogs want items priced that they can mark up at least four times.

• www.artfulhome.com. If you want to sell to interior designers, this is a great site to check prices on. Some pieces listed here sell for thousands of dollars.

• www.wholesalecrafts.com. This site lists craft items for sale to wholesale buyers like stores and galleries. Although it won't tell you what items are selling, it will give you an idea of prices other artisans are asking.

• www.amazon.com. As you are probably aware, Amazon sells (or lists for sale) almost every kind of item you can think of, including handmade products. Go to their site and type in 'handmade' in the search box. Make sure you are searching 'All Departments.' Then go down the left column and choose your target category. For examples, see categories like jewelry, toys, gift cards and more. After choosing a category, sort the results by price, high to low (this sort moves the low-priced and often imported handmade items to the end of the results.) Sort by popularity and average customer reviews to get insight into what's selling.

• www.qvc.com. In the search box, type in a craft item similar to what you make like "birdhouse," "quilt," "ornament," "decor idea," or just type in "handmade". Note, some results may not be handmade in the US. Note the prices the items sell for. QVC buys in quantity and then resells stuff at a marked up price. QVC has been around on TV since 1986 and are very good at buying items that sell.

If you plan to sell at craft shows, you will have to go around physically to several and check prices that items similar to yours are selling for. There's no online alternative to the leg work needed. Researching a few shows will tell you the average price of produces like yours; usually around the most you want to ask at craft fairs you do. If you exceed the ceiling price by much (unless you use the techniques mentioned in this book about raising perceived value) it will be tough competing with those sellers pricing their products lower than you.

Within the marketplace for selling crafts, it's normal to discover one average market price for an item is higher than it is for similar work in a different market(s). For example, Etsy prices may be lower on average than an item sold at fairs, shown in catalogs, or sold to interior designers.

Though we mentioned Wholesalecrafts.com, it is by no means the definitive source for wholesale price guidelines. Back in your car again to go around checking stores and galleries who sell stuff like yours. You can safely assume that the prices a store is asking is at least twice what they have paid. Your challenge is to know if you can afford to sell your work at fifty percent of the store's asking price and still make a profit. Figuring the floor price, which is explained shortly, will tell you if you can.

Some craft artists use the market average as a pricing strategy indefinitely, which works as long as you cover your costs and earn a decent profit.

If you are doing a show in a town where you have store accounts, you will want to keep your retail prices the same as what the shop asks. Many

store owners visit the fairs looking for new work.
If your work is in their store and they see you
undercutting their prices, you could easily lose the
account.

Cost of Goods

Cost of goods is the dollar amount you spend to make products that you sell. This includes all material and labor involved, but not the fixed costs explained later. Cost of goods, when subtracted from your gross sales, leaves an amount known as your gross profit.

Material costs. Examples of material costs include: *For a weaver:* yarn, thread, accessories, dyes. *For a stained glass artist:* glass, solder, lead, finishes, paints. *For a woodworker:* wood, glue, screws, pegs, sandpaper. Whatever your craft, don't neglect to include the costs of everything that goes into the making of each piece.

Your material costs may be variable over time because costs change with the number of items or kind of products you make. You might have to run to Hobby Lobby and pay retail for something you just ran out of. Or, you may end up paying less for supplies when buying in large quantities from wholesalers. See Chapter 8 for tips on slashing your material costs.

When determining material costs per item, be sure
to add shipping charges you paid when receiving
them and any sales taxes you were charged to the
total bill before dividing by the number of items
you received.

When you use small quantities of glues, paints, and so on, it may not be practical to try and figure these exact amounts.

It's more effective to estimate their cost by averaging their use over time. For example, say you produce fifty dolls the same size over a period of three months. You used three tubes of paint at $3.50 each, two and one half bottles of glue at $4.95 each, three yards of fabric at $4 per yard, 1 yard of ribbon at $8.00 per yard and two yards of lace at $6 per yard. The bodies and heads of the dolls cost $3.87 each. Following is an example of how to figure your material costs:

50 doll's heads at $3.87 =	$193.50
3 tubes of paint at $3.50 =	$10.50
2.5 bottles glue at $4.95 =	$12.38
3 yards fabric at $4.00 =	$12.00
1 yard ribbon at $8.00 =	$8.00
2 yards lace at $6.00 =	$12.00
Total materials =	$248.38
$248.38 divided by 50 = $4.97 per doll	

Total material supplies used for each doll is $4.97. Now double that amount before you add this figure into calculating your final price. Why? Because if a person were to purchase these items themselves, they would pay full retail which is twice what you pay when you buy supplies wholesale.

Cost of labor. Cost of labor is the dollar value you set for your time in producing your craft and operating your business. It should also include money you pay to employees or independent contractors who do work for you. To learn the hourly cost of your labor, record the hours it takes to make an item. Record yourself several times because you need a realistic average. Almost everyone works at different paces over time. I am sure you have had days when you seem to accomplish more than at other times and the opposite kind of days we won't go into.

I create a Project Log record, like the example following,

for every item I make. It reminds me of the hours it takes to complete a piece. Such a record will also tell you how much time it should take employees to produce a piece if you do hire outside help.

Product Title:

Materials:

Photo/Sketch:

Instructions:

Finishing:

Labor Cost:

Total Production Cost:

Retail Price:

Gross Profit:

Notes:

How do you rate what your time is worth when you go to determine your cost of labor? There's no definitive answer, but I would not start at less than minimum wage which could have changed by the time you read this book. If you figure you are worth $15 an hour, you are probably right. If you figure you are worth $30 an hour, you are probably right. Start with the hourly rate you are comfortable with. As you gain more experience, sell more pieces, win awards, get mentioned in the news and your brand becomes more recognizable, you will probably feel instinctively how much and when to raise your personal hourly rate.

When you are calculating an hourly labor rate, add in an additional thirty percent to that rate cover employment taxes. The thirty percent is an estimate suggested by the Small Business Administration. It includes the average amount you also pay as an employer in Social Security deductions, workers compensation costs, unemployment insurance, bookkeeping, and additional paperwork. If you provide health insurance or a retirement plan for yourself or workers, this amount needs to be accounted for, too.

For instance, you are creating the dolls we just mentioned and you do not hire labor of any kind. You decided that you want to pay yourself $10 per hour. If it takes you two and one half hours to make one doll, figure your cost of labor as:

2.5 TIMES $10 = $25.00
$25 TIMES 30% = $7.50
TOTAL LABOR FOR ONE DOLL = $32.50

Chapter 9 teaches you how to reduce labor costs by getting more out of your time and workspace.

Indirect Costs or Overhead

Indirect costs or fixed costs, sometimes called overhead, are those expenses you pay to operate your business on a day to day basis. In general, these expenses tend to remain in a predictable range throughout the year regardless of how much you sell. Examples are licenses, rent, utilities, phone, insurance, advertising, bank charges, office supplies, cleaning supplies, professional dues, and so on.

If you are like most craft artists who work from home, you can probably take a shortcut when determining how much of these indirect costs to account for in your prices. The quick and dirty formula is to add cost of materials plus cost of labor and then figure 25 percent of that to arrive at a number that will cover your overhead. When you are starting out, you don't really know what it will cost you to do business because there are bound to be expenses you can't foresee. You will also have only a rough idea of how and when your sales will come.

For those already producing and selling so much that you rent studio space, have employees, business insurance and the like, see the more advanced accounting described in the latter part of this chapter.

Cost of Sales

We have looked at material and labor costs, but there is another expense to keep track of called the cost of sales. Cost of sales accounts for things like credit card or Paypal processing fees, listing and closing fees for sites like Etsy and eBay, craft show expenses, and sales rep commissions. You may or may not have all these costs in your business but most of us will have at least one.

Credit card processing fees. It's almost a necessity to offer online shoppers the options of paying with their credit card or Paypal account. The fee varies among merchant account providers but count on it costing you around 3.5% of the amount your customer pays. Most merchant accounts charge other fees as well. Typically, there is a set up charge and a monthly maintenance fee which can run up around $70 to $80 a month.

Listing fees and commissions. When selling online, you will pay listing fees and sales commission fees for most sites like Etsy and eBay. Listing fees are often tied to the dollar amount of your item. You pay less money for listing items under a certain dollar amount and more for higher priced products. Closing or final commission fees vary from site to site, ranging from zero to 10 percent of your selling price. For example, at the time of this writing, Etsy charges $.20 to list an item and 3.5% sales fee when/if the item sells. Artfire charges a flat $11.95 a month with no listing or sales fees. Craftsu.com is free to list, promote and sell as many items as you want.

Craft and trade show expenses. Depending on how many craft shows you do every year, you may want to choose between adding up all the costs associated with doing a show—gas, food, motel, booth rental fee—and subtract it from total sales to come up with a cost of sales per show. Or if you do many shows a year, you could add up those expenses and instead of calling them cost of sales, consider them as part of your business's indirect costs/overhead.

For example, at a recent show, you spent $75 on gas, $100 on a motel for two nights, $400 for the booth rental and $60 for food for the whole time you were on the road. Your total expenses came to $635 which is your cost of sales. You only

took in $1,480 in sales, so though you made money, it wasn't much. Hopefully, you enjoyed doing the show anyway.

If you do wholesale trade shows, your booth fees can run into the thousands after travel, paying union workers to unload and load your display, utilities, internet, and more. However, these events are attended by wholesale buyers from all over the country who are looking for unique items like yours. If you are considering trade shows, you should be able to produce in quantity and on a predictable schedule. You must also be able to live with the delayed payments for your goods that are typical when doing wholesale business. Most importantly, you better have run the numbers like we do in this chapter so that you know exactly what it costs you to produce your products.

Sales rep commissions. As an alternative to trade shows, you may want to use sales reps to open more store accounts. In general, sales rep fees come to between 10% and 30% of the wholesale price. Commissions you pay out to reps must then be accounted for in your pricing formula.

For example, you sell small toy soldiers for $4 each wholesale. You hire a rep on commission to open new accounts and you agree to the rep's terms of 15% commission on every sale. In this case, your cost of sales is found by multiplying $4 times 15% which equals $.60 on each item. Subtracting $.60 from $4 equals $3.40, the amount you have left after each sale through the rep. Can you afford to sell a toy soldier at $3.40 each?

A sales rep may be willing to discuss your wholesale prices with you based on their experience in the market. As long as you know your floor price and your cost of sales, you can make a decision whether working with a rep is going to work.

Figuring the Amount You Must Recover

While the average market price for your products is the ceiling price or the most you will charge, the formula below will give you the floor price or the lowest price you can safely charge for an item. The floor price insures that you recover your invested expenses and make a fair profit. The floor price accounts for:

• Cost of goods, that is, the total of your material and labor costs for each item.

• Cost of sales; how much does it cost to sell the item.

• Indirect (overhead) costs associated with running your business on a day-today basis. Overhead is also called fixed expenses because you pay them regularly whether you sell anything or not.

The formula for figuring the floor price is:

COST OF GOODS (SUM OF MATERIAL + LABOR COSTS)
+
COST OF SALES
+
INDIRECT COSTS (25% OF COST OF GOODS)
=
MINIMUM PRICE TO RECOVER YOUR COSTS

For example, you want to know your minimum recovery amount for a set of earrings. You learn that your labor cost is $12 and your material cost is $2.35, which added together equals $14.35. You list the item on Etsy for $20. Etsy charges you $.20 to list and 3.5% when it sells for a total of $.90 for cost of sales. You work at home so you elect to estimate your overhead as 25% of your production cost which comes to $3.58. Here's what the numbers look like using the formula:

COST OF GOODS $14.35 (MATERIAL $2.35 + LABOR $12 FOR 1 HOUR)
+
COST OF SALE $.90
+
INDIRECT COSTS OR OVERHEAD $3.58
=
MINIMUM PRICE TO RECOVER COSTS $18.83

The floor price isn't necessarily or always equal to what you eventually price the item for. The research you did earlier to learn the average market price for similar work may indicate you can charge more. Or your research may show that you can't compete with your current costs so you have to look at making other items that you can sell for higher prices or find ways to lower your costs, like those described in Chapters 8 and 9.

Learning the minimum or floor price is essential to knowing if you have enough of a profit margin to sell wholesale. Figure the floor price of every item you make to determine if your current prices are realistic.

My first year selling, I priced pieces without accounting for all my expenses. I basically guessed at the amounts I should charge after checking what the average price was for work like mine. When I finally did look at the expenses incurred from all the shows, my labor, and overhead, I found I was producing my handmade work for about $3 an hour. After learning that, I began upgrading the perceived value of my items with better materials, more attractive hangtags, and some of the other suggestions described in these pages. I was then able to raise my prices without losing any business, which led to an increase in my hourly earning.

Once you have determined the price for each item you make, record it on the Project Log form or some similar form that helps you track your costs and labor.

Advanced Look at Indirect Expenses

The remaining sections in this chapter are optional and probably of little interest to the average home based craft business owner. However, the more your business grows, the more important it becomes to track indirect costs in detail and in a consistent manner. After you've been in business for a year, you will have records of enough operating expenses to make a good estimate for the next year. The following sample shows fixed costs for a sample business over a one year period.

Expenses	Per Month	Per Year
Advertising	$20.00	$240.00
Auto	$100.00	$1,200.00
Cartons	$10.00	$120.00
Freight	$20.00	$240.00
Insurance	$30.00	$360.00
Bank Fees	$20.00	$240.00
Laundry	$15.00	$180.00
Licenses		$40.00
Miscellaneous	$30.00	$360.00
Office	$10.00	$120.00
Postage	$16.00	$192.00
Rent	$250.00	$3,000.00
Rent - Booth Fees	$400.00	$4,800.00
Repairs	$10.00	$120.00
Phone / Internet	$45.00	$540.00
Publications	$10.00	$120.00
Travel	$200.00	$2,400.00
Utilities	$95.00	$1,140.00
Total	**$1,281.00**	**$15,412.00**

Hourly Cost of Doing Business

We want to know the hourly cost of doing business which accounts for all the above costs. Divide $15,412 by the total number of hours worked in one year. For example, if you work

40 hours a week, 48 weeks a year, the total number of hours is 1,920. Divided into the total yearly fixed expenses of $15,412, the result is an hourly cost of doing business of $8.03 per hour. This $8.03 is an additional cost you are paying over the amount of your labor and materials.

Returning to the example of the set of earrings from before, below is what the numbers look like when accounting for the specific hourly cost of doing business instead of estimating overhead as 25%. As you can see, the final minimum price of the earrings is now much higher than in the previous example. This demonstrates why you will want to run the numbers both as a percentage and as a detailed hourly cost of doing business using your own expenses so you can arrive at precisely the right price.

COST OF GOODS $14.35 (MATERIAL $2.35 + LABOR $12 FOR 1 HOUR)
+
COST OF SALES $.90
+
INDIRECT COSTS OR OVERHEAD $8.03 FOR 1 HOUR
=
MINIMUM PRICE TO RECOVER COSTS $23.28

I used 'hours you work' as a divider because your labor remains a constant. If you divide your expenses by the total number of pieces you make, the resulting dollar amount does not account for the specific labor costs of making different items. For instance, it may take you two hours to make one item and 4 hours to make a different product.

One of the advantages of working from home is that the use of part of your home for your business may be deductible if you meet IRS requirements for such a claim. See Chapter 10 for more about tax deductions.

It is important to determine your fixed expenses and hourly

rate of doing business at least once a year. Rent and utilities go up, you may be spending more on long distance than last year, or you may have purchased newer equipment. To recover these costs, you must continue to keep account of them and include the most up-to-date figures in your pricing formula.

Knowledge Leads to Profits

If you take the action steps outlined in this chapter and research your average market price and your cost of goods, you can price your handmade products with confidence that you are not losing money. You will also be in a position to determine ahead of time whether to launch a particular product or not.

Here are three ways knowledge keeps you on top of your business at any given time:

• Every few months, research prices of competing sellers of items like yours.

• Tune in to what your customers are saying. Take note of their comments on your prices when they are browsing your booth or leaving comments online.

• Do a cash flow statement (described in Chapter 7) and update it every month.

Key points to remember when formulating your prices:
• Understand retail and wholesale pricing
• Research average market prices for work like yours
• Cost of goods = cost of materials + cost of labor
• Cost of sales = what it costs you to sell an item
• Indirect costs or overhead = 25% of your cost of goods
• Add the three above to get the amount you must recover
• Know your hourly cost of doing business
• Remember that knowledge of what's going on with

your business that you get from keeping good records, leads to profits.

Numbers don't lie, but many small business owners lie to themselves imagining that they can keep all the numbers in their head and then painfully discover they haven't really done the necessary homework. I hope you will avoid this costly mistake and keep track of your expenses. The next chapter show you how to go beyond just recovering your costs through your prices, but how pricing can be used in a variety of marketing strategies.

Chapter 4
Competitive Pricing Strategies

"Whoever said money can't buy happiness didn't know where to shop." ~ Gittel Hudnick

The previous chapter gave you the formula for learning what you have to make from your items to recover your costs. Once you understand the formula and are applying it, you are in a position to use your prices as part of your overall marketing. This chapter introduces pricing strategies; situations where your prices act as sales incentives.

Strategic pricing includes:
- Knowing your customers
- Using popular price points
- Listing a range of prices
- Pricing for online stores
- Pricing for shows and events
- Holiday and seasonal pricing
- Offering discounts
- Providing add-on services
- Offering free shipping
- Should you haggle over prices?
- Is your price is too high?

Knowing Your Customers

The most profitable business owners learn about their prospective customers; what shoppers like and how much they are accustomed to paying for these products. To make it easier,

think of consumers as three basic groups:

 1. Those on budgets hunting for bargains

 2. Those in a hurry seeking ease and speed

 3. Those who are status driven

You will have more success promoting your items when you position them in front of the appropriate group of shoppers, priced according to the consumer's buying habits.

In the previous chapter, we described how important it is to learn what items like yours are selling for in all of the markets where you sell. Researching prices should be an ongoing part of your marketing plan.

The more you know how much consumers will pay for products like yours, the more profitable your business will be. You may be leaving money on the table by pricing your pieces incorrectly.

When you have learned the average market prices, play with your own prices—up and down—to see how much give there is. In other words, if you raise the price slightly above the average market price, does it adversely affect your sales?

Using Popular Price Points

When placing price tags on items, even dollar figures are perceived as more elite. A discount store might tag an item at $24.95 and a gallery would price the same product at $25.00. My woven garments retail at $80, $125, $150, and $250. My large rugs sell for $500 to $800. I've always felt that asking $499.95 would somehow cheapen the item.

There are a few origin stories of how items priced with .99 at the end got started, but several sources

agree that it was started by store managers as a way to force their employees to open the cash register drawers for each transaction to give change, so workers couldn't just stick dollar bills in their pockets.

When answering a customer who asks about an item's price, share the benefits or value of a piece, too. You never want to avoid answering a pricing question, but it's a good opportunity to explain to the customer what they will be getting when telling them what they must pay.

Listing a Range of Prices

Whether you sell online or off, offering a range of items priced from low to expensive is a strategy that attracts customers with a variety of budgets. If you only sell high-end pieces, you will only get shoppers with big wallets. If this is you, look at how you can come up with a line of budget priced products to attract a whole new group of customers. Supplement your inventory of higher priced crafts with smaller items within a price range of $10 to $20. At shows where sales of high-ticket pieces are slow, I have found offering a range of low priced items has saved the day.

Pricing for Online Stores

There is no shortage of competing products for sale on the popular online shops like Etsy. As mentioned in Chapter 3, research what craft artists are charging for work like yours. You will have to check scores of listings, but look to successful sellers for examples.

Etsy, Artfire and other online shoppers rely on seller ratings or feedback ratings before making a sale. If you are a new

seller, you don't have feedback yet, so shoppers are cautious about buying from you. Start building up your feedback ratings by offering cheaply priced items to get some initial sales. Once you have good ratings, it will be easier to sell your more pricey products because you have built up some trust.

If you make inexpensive things, you could price all your items at the low end of average prices for similar items offered on the same storefront. You can then attract cost-conscious buyers. This approach is sometimes called *lowballing* and is much more effective with crafts priced from $2 to $20.

Heartsy.me provides listings of daily deals from Etsy sellers. Think of it as Groupon for Etsy. If you have a big inventory and can afford to heavily discount your items (think: selling at wholesale prices,) Heartsy can get you lots of new customers quickly. But you must know your cost of goods or you could easily find yourself losing money.

In the previous chapter, you learned how to determine the minimum recovery cost for each item so that you make a profit. For a specific example of how running a campaign on Heartsy would affect your business, see http://www.handmadeology. com/heartsy-calculator-know-your-numbers-or-you-could-lose-money/ Feedback from Etsy sellers includes those for whom it doesn't pay off and those who were happy with their results.

Do the numbers for your business to learn if working with Heartsy is a good choice as a promotional venue for gaining new customers who might buy other items from your store.

Like with online stores like Etsy and Artfire, eBay shoppers look to a seller's feedback rank before placing a bid or buying from an eBay store. The same advice applies here: start out selling cheaper items so you can get some positive feedback built up.

Your own website is like your store; charge prices as if you were selling at a craft show booth or from your home studio. However, if you sell through multiple markets, try to keep your website prices consistent with your other venues.

Pricing for Shows and Events

Position your crafts in markets where customers arrive with a set of perceived values and price expectations already in their minds. For instance, display your goods at one of the better, juried fine art/craft show. Customers at these shows are willing and even expect to pay more than they would for mass produced items. Another example is getting your work featured in galleries along side high priced items. Mail order catalogs that features quality crafts like those mentioned above are another place where customers have expectations of a higher price range. Each market has its own loyal customers.

As you may have already found, different kinds of craft shows attract different groups of shoppers with whole different sets of preconceived notions about what they are looking for and how much they will spend.

You may find pieces selling in stores but not at art and craft shows, and vice versa. Many items simply don't sell in every market. But this doesn't mean the products won't sell elsewhere.

In my beginning years, I once read a glowing review in a craft fair guide of a show in a city 600 miles from me. This guide did not, unfortunately, distinguish between the different kinds of shows reviewed or the average price range of items sold. I was still too new to know there are a variety of shows

and how important it is to know what kinds of crafts are shown and what kind of crowd attends.

This particular show attracted country craft makers and country craft buyers expecting country craft prices. This would have been a terrific if I made country crafts, often priced between $5 and $50. But I didn't. I handwove garments and rugs. My average piece retailed for $150 while the average craft item at this show retailed for $30 or less. I sold almost nothing. There was one sale to a visitor from Germany who was someone's guest. He recognized the quality of my work without the preconceived set of values or price expectations most of the show's attendees arrived with. The very next weekend, we set up at an event in another town near the first in a juried show. This event brought in over $3,000 in sales and most of those were our best pieces. This juried event drew crowds who arrived expecting to find high end pieces.

Read as many different reviews of fairs as you can find. Talk to recent exhibitors. Be discriminating when selecting which shows to do. Find those shows which bring in customers looking for the type and price range of crafts you make. Even after you have done all your homework, you can still occasionally get caught in a poor selling show. Discounts anyone?

Holiday and Seasonal Pricing

As with most retail products, handmade items experience seasonal sales swings, with pieces selling more in the gift buying months leading up to Christmas. According to the American Research Group, the average consumer spent around $650 for holiday gifts in 2010.

Holidays are a good time to boost your income per transaction by offering add-ons like gift wrapping, holiday gift baskets,

or special shipping rates. Holiday shoppers are typically in a hurry. If you can offer fast solutions to their gift buying needs, you'll get their business. For example, offering a discount for buying several units of the same piece can not only save the buyer money, they can conveniently get all their shopping done from one source—you.

If your work is susceptible to seasonal slumps, look for additional items to sell at those seasons when your other sales fall off so you can have something going all year long. Unless you only want to work a few months a year. I know one craft maker who only sells from October through December.

With online markets, don't rush to discontinue listing items just because their season has passed. For example, you would think Christmas ornaments would only experience strong sales in the months and days leading up to December 25. Researching eBay awhile back revealed that between February 12 and March 12, there were more than 4,000 eBay auctions with 'Christmas ornament' in the title which completed successfully at an average selling price of $17.34.

That's great news if you make Christmas ornaments and want more sales year round. In that same period — and remember this is an off season month — I found 1,793 completed auctions with 'halloween' in the auction titles, with an average selling price of $32.11. For auctions with the word 'thanksgiving', 164 items sold at an average price of $7.91. However, displaying seasonal merchandise past their season at craft fairs will work against you.

Some locations are better selling markets at different times of the year. During the winter, many people travel to Arizona and Florida for *the season*. San Antonio is a big convention city, hosting events throughout the winter months. The city draws

northerners from all over to warmer January, February and March months of south Texas.

Learn which months attracts tourist season for various shops around the country, especially those located in scenic places. Ask store owners what their busy times of the year are. If a store is in a popular tourist locale, you can often command higher prices. Refer to the shop buyer for pricing suggestions.

Offering Discounts

Thinking of running a special sale? Below are twelve types of discount offers that allow you a variety of ways to kick up your sales by lowering prices. Before offering sales, special deals or discounts, know your recovery cost for each item, so you don't lose money when selling at lower prices. More importantly, read the *CAUTION* section immediately following this one before adopting any discount policy.

Limited time offer. Offer shoppers a savings from your normal prices for a limited time. The urgency of a limited time offer spurs buyers to buy now for fear of losing out on the savings. But you have to tell them to hurry in your descriptive copy. For example, "hurry (or don't miss out), you get the following savings only as a *Limited Time Offer,* good only until...."

Quantity discount. Offer a break for purchasing in large quantities. This tactic can also attract wholesale buyers. For example, "when you buy four or more of this item, you get 10% off."

Minimum purchase discount. Similar to above, you can entice shoppers to get their order dollar amount higher by proposing a dollar amount savings. For example, "when your purchase amount totals $200 or more, you receive 10% off."

Buy one, get one free. Though worded differently, this is

essentially another form of quantity discount. For example, "order one by [specific date] and we'll send you another one free."

Season-based price breaks. As described earlier, holidays are prime shopping times. To grab more business at these times, propose a special holiday price. For example, "our holiday gift to you is 10% off from now until [specific date]. Calendar based discounts can work well at other times than holidays; they also can be based on a day of the week. For example, "we're feeling good this week and want you to also, so if you order by or on Friday, you'll get 10% off."

Cash discount. If you can accept cash for payment (doesn't work with online sales unless you can refer customers to a physical location nearby) as opposed to credit cards or checks, offer a cash discount. For example, "pay with cash and get an instant 5% rebate."

Military discount. Families of veterans deserve every break they can get. Providing a discount to someone in the military establishes goodwill for you with the community. For example, a trade discount may be offered to a small retailer who may not purchase in quantity but nonetheless performs the important retail function.

Senior discount. Senior discounts are very popular among retailers so offering specials to the over sixty crowd will attract their business. For example, you could have one day of the week be 'seniors' day' and give a twenty percent discount.

Introductory offers. When a product you make is new to the marketplace—that is no one else appears to be making something like it—and you are first introducing it, you may find it helpful to offer a special introductory sale to get interest started. But put a time limit on the intro offer and be sure to quote the price the item will be after the introductory special ends.

If a new product requires consumer education, be sure to provide it and let shoppers know they will get everything they need to know. For example, you are coming out with a new fashion accessory; provide a video or slide show with ways to wear the new item.

Loss-leader pricing. This tactic is only for the brave. You may attract additional customers by pricing some of your pieces at cost or lower. Though you may actually lose money on a few pieces, this tactic can be used to bring in new buyers who may eventually purchase more profitable items.

Say you advertise a packet of dried herbs and flowers at a special price of $2 and it cost you $2.50. These packets are displayed with your new line of handmade collector vases priced at $49, which is what you really want your customer to buy. Loss-leader pricing can be effective when you follow up with previous customers with a special offer like through a postcard mailing or sending out an email blast.

Coupons and rebates. Coupon and rebate offers have really taken off with the rise of sites like Groupon. As mentioned earlier, Heartsy.me is a program that helps you reach more customers if you can afford to offer deep discounts.

Use Caution When Discounting

As a pricing strategy, only consider discounting your prices when you're one among many listings or displays of similar items or as a temporary way to boost sales. Many buyers of handmade products like to support the artists who make things and don't mind paying a little more to support those involved in right livelihood.

Chapter 2 offers many ways to increase perceived value to get your pieces to stand out before you consider discount-

ing your prices. Always look at improving the value of an item before diving into a price war.

Discounting at craft fairs should be looked at from show to show. For example, say there are twelve booths at one event selling leather belts of similar construction. A shopper has walked around, makes a judgment that there are many booths selling the same thing, and then starts looking for the cheapest belt. If yours was the only booth showing leather belts at an event, prices would not matter to her as much.

It's tempting to imagine that an item isn't selling because it's overpriced. There is a tendency among new artisans to mark down their products in an attempt to help the situation. However, this often fails to produce the desired result. What works for large retailers selling mass-manufactured goods does not apply across the board when marketing handmade crafts. If your products are perceived as valuable to the shopper, you will probably find they are just as willing to pay $25 for a handmade item as they would pay $20. I have often found that a piece sold faster by raising the price, than by lowering it.

Another reason to be cautious with discounting is that when a shopper sees too many discount price tags, they may reject the pieces as somehow being inferior without looking closer.

Providing Add-on Services

When faced with competition, offer more services than others. Provide gift wrapping, free delivery in the city, coupons and gift certificates, or a lay-a-way plan. Lay-a-way is where the customer puts a deposit down, usually fifty percent. The customer then makes payments on a monthly basis until the piece is paid off. You keep the item until the customer sends the final payment.

Offer speedy delivery or rush service for online customers. But at craft fairs, whenever a customer is in a hurry for a special order, quote a price that includes an extra markup for rush service; say at least 10% more than the typical price would be. This is quite common in almost all other services and usually expected. For instance, if you go to a local printer and ask for a rush job, they quote you a price that is above the normal price.

Offering Free Shipping

In most online transactions, customers expect to pay shipping costs, except in cases where you specifically offer free shipping as an enticement. Offering free shipping when a customer prepays an order can be a good sales incentive and many of your competitors aren't doing it. However, a survey showed that free shipping was the number one most requested service by online shoppers.

Know for certain that you can afford to provide free shipping before you offer it or you will quickly find yourself wondering where all your profit went. Track the amount you pay to the post office, UPS, or other freight services and determine what percentage of your final selling price it made up.

For example, you run a special offer for free shipping on your knitted hat and scarf set priced at $32. It costs you $4 to ship, which leaves you with $28. Does this amount cover your other costs? If not, consider raising the price by $4 and continue to offer free shipping.

Shoppers may not object to paying for shipping but they often resent paying an extra handling charge. They almost always see handling charges as a way businesses gouge the customer. The exception will be when you are shipping fragile pieces like glass or pottery.

Should You Haggle Over Prices?

Every crafter who has done a few shows has been approached at the booth by at least one customer who wants to haggle down prices. If you are new to the business, it's easy for a clever bargainer to get you to feel and speak apologetically about your pricing. Just remember to not take it personally. These types try to negotiate the price on everything else they buy, too, not just your work. In of itself, that's not a bad way to approach making a purchase. But why should you apologize for charging what you do for your art or craft? You spent considerable time and money to produce your pieces and you should receive fair payment in return.

This doesn't mean you can't bargain. The question is whether you should. The more years you have in the business the more confidence you have that your prices are fair and the less likely you will adopt bargaining on a regular basis. You know that you don't sell everything at one show and that there will be other shows down the road.

> *"No one should drive a hard bargain with an artist."* ~ Ludwig van Beethoven

New exhibitors might think it better to sell pieces at a discount when the show is ending just to move more items. The problem is once you start agreeing to bargain with customers, and therefore encouraging them to bargain, you derail the value of your work in your own eyes as well as anyone happening to be looking on at the time. How will you answer the customer who overheard you offering a discount who asks, *"You gave her a bargain, what are you going to do for me?"*

A better option is to have pieces with slight faults on hand at discounted prices. Have the discounted pieces tagged with the full price marked down. Show the bargain seekers your sale rack.

Is Your Price too High?

How do you know when you have gone too far with raising your prices? The answer is simple. You have raised your prices too much when sales start to decline. (That is assuming you have already followed the suggestions for increasing perceived value so that it isn't some other reason your sales are suffering.)

When you see this happening, go back to the price point where sales held steady and stay there until you learn that your competitors have all raised their prices.

If you notice over time that demand is weakening and sales are declining, it may be time to lower your prices slightly. When demand increases again, raise your prices. Continue raising prices over time until you find customer resistance or sales decreasing.

Try a couple of shows or online listings until you learn how customers respond. If there's no resistance to the prices you're asking, you can probably raise them. Periodically shop the handmade marketplace to learn what other crafters are pricing for similar work.

As a long term way of thinking about your business, the only way to really know what works is to keep testing prices from time to time, measure what happens and then apply what you learn. Here are some important takeaways from this chapter:
- Know your customers
- Use popular price points
- List a range of prices
- Take advantage of holiday and seasonal pricing
- Offer discounts, but only for limited times

- Provide add-on services
- Consider offering free shipping
- You know your price is too high when sales drop

Surviving VS Thriving

This chapter showed you sales-increasing strategies through pricing. But there may be challenging times when you have to put aside aspirations to just get by. Perhaps the demand for your items has diminished or there are too many competing craft artists making the same things. If you find yourself surrounded by competing sellers, your aim then is to select a price that will cover all of your costs and stay in the marketplace from month to month. Simply surviving may take a priority over your longer range profit goals. If this happens, the discounting strategies we explored will come to your aid, if even only temporarily, until you can either find other less crowded markets or products to make that haven't attracted an army of other sellers.

One way out of the battlefield of sameness among craft products is to create truly one-of-a-kind pieces. These lovely treasures have their own pricing system which you will learn in the next chapter.

Chapter 5
Pricing One-of-a-Kind Pieces

"An artist is a creature driven by demons. He doesn't know why they choose him and he's usually too busy to wonder why." - *William Faulkner*

For many makers of handmade products, creating and selling low-priced and easily reproducible items pays the bills. At the same time, there can be a yearning to expand horizons with one-of-a-kind work that sells for high prices. The approach for pricing unique pieces requires special attention.

Many craft artists feel that each of their pieces are one-of-a-kind and in some cases, rightly so. This chapter helps you value items that are typically shown in galleries, art in public places programs, or purchased by corporate art buyers. Works of this nature fall into the category of art arising from the finest craftsmanship, as opposed to products that can be duplicated again and again through production techniques. This chapter covers:

- What other artists charge for similar work
- As your brand grows, so can your prices
- Working with galleries
- How to account for broker's fees
- Pricing by the square foot
- How to price commission work
- Sample request for quote

What Other Artists Charge for Similar Work

It's important to look for examples of unique items for sale in your craft media. The price range is all over the place but targeting your specific art form will help you get a sense of where to start. For example, one-of-a-kind handmade collector dolls sell from $8,300 to $11,000 according to Dollery.com. Artfulhome.com lists one-of-a-kind glass wall art at prices ranging from $495 to $14,000 and one-of-a-kind furniture from $395 to $22,000. I found a handcrafted toy car described as one-of-a-kind on Amazon retailing for $84.

As Your Brand Grows, So Can Your Prices

So much of effectively being able to sell one-of-a-kind items and command high prices rely on how well known you are. There's no formula for matching your reputation to your prices, but you can look to famous artists as examples of what's possible. Maria Martinez became so well known for her pottery, she was invited to the White House by four different presidents. Her journey to fame is reported on at: http://www.medicineman-gallery.com/Maria-Martinez-article.lasso

As mentioned earlier in the book, cultivating a brand that makes your body of work instantly recognizable allows you to raise your prices commensurate with your name recognition. This becomes even truer when you produce and sell high end once only pieces.

It has taken years for some artists to achieve the notoriety they have so don't expect it to happen for you overnight. But the world is getting smaller so who knows what you may achieve.

Increasingly used by the majority of consumers, the Internet provides multiple ways to get your name out there and connect directly to your buyers. Becoming recognizable can be

accelerated through use of Facebook pages, Twitter, blog posts and a host of other social media.

Getting mentioned in the news and written about in magazine reviews, otherwise known as PR or public relations, gets your name in front of millions of readers. Marcia and Bill Finks create figures from rusted steel and other found objects. Their pieces have appeared in numerous national publications and they have exhibited their work at various Art Institutes and Museums as well as *Country Home, House Beautiful, Home, Country Living, Elle Decor, Newsweek* and various publications. Their art has appeared on Oprah Winfrey, House and Garden Network and the popular TV series Party of Five.

Working with Galleries

Many one-of-a-kind pieces are sold through galleries. Talking with an established gallery's manager can help you determine a piece's price because they have come to know their clientele over time and know what their customers will pay. Keep in mind that gallery owners are firstly concerned with getting sales. Because a major consideration in pricing art or high-end craft art is the reputation of the artist, a newer artisan's work may not get the same treatment as a proven seller in a reputable gallery.

A good way to start is to personally shop galleries looking for pieces similar to yours. You may be able to get the gallery manager to show you the resumes of artisans with work like what you do. By looking at the background of other artists and noting the prices asked for their work, you may be able to estimate what you should be charging. Remember that the gallery is adding a markup to all work shown, probably around 100%.

When presenting your work to a gallery or dealer, have a price sheet with suggested retail prices. For instance, say

you've created a sculpture which your price sheet will show a suggested retail price of $1,000. Then, you would receive $500 from a 50/50 split with the gallery.

Broker's Fees

Like sales reps to gift stores, there are brokers who sell art to galleries and corporations. If you are working through a broker to reach and sell one-of-a-kind pieces to galleries, the commission you would pay them should be added to the total price when you first make a bid or quotation on a job.

There is a simple formula for adding the agent's percentage that gives you the required price. Say that you want $4,000 for a piece and the agent will receive 33% as commission. You need to find the total amount that subtracting 33% from that will leave you with $4,000.

Divide the $4,000 by the percentage going to you (100% - 33% = 67%, or .67). $4,000 divided by .67 = $5,970. To check it, simply subtract 33% (.33) of $5,970. This gives you $1,970 for the agent and $4,000 for you.

Make sure you have also added in time you spent creating any models or samples, meetings with the designers, delivery, and installation costs, if any.

An excellent way to successfully market one-of-a-kind pieces is to maintain a customer mailing list and mail postcards when you create new pieces or you have a show coming up near where the customer lives. Many collectors are absolutely obsessed with owning a series of pieces by their favorite artists.

Pricing by the Square Foot

Some professional artists and fine crafters quote on commissioned work at a set rate by the square foot or by the square

inch, for smaller media. When pricing for three-dimensional media like pottery or sculptural objects, consider the item's size, complexity of form and complexity of surface design. If you price per foot, your accuracy will improve with experience. When you don't have the experience, turn to examples of someone in your media who is well known and learn what they charge.

I came across a fiber artist creating large tapestry pieces who charges $100 per square foot or more. This artist knows her labor, studio expenses, material costs and very close to how long it will take to complete the commissioned piece. A stained glass artist might charge $120 per square foot based on a different set of costs such as amount of glass and other materials and supportive construction required. Pricing by the foot or other measurement has to recover the various investments you make like those described in the following sections.

How to Price Commission Work

After you have put your name and reputation in the marketplace to such an extent that brokers, interior designers, and architects know who you are, where you are and what you do, you start to receive more opportunities to bid on commissioned work. These purchasers invest in an artist's future success and reputation, as much as the work they buy today.

Success in the interiors and corporate marketplace revolves around professionalism. Part of that professional image is giving a confident presentation of what you can do. Corporate buyers look for and expect consistent price quotes.

Suppose you're commissioned to do a new piece that is not a purchase of an existing work. How do you quote on the job? Here are the elements to include:

• How closely can you estimate your labor required?

Remember, there is almost always a deadline for completion of commissioned work. Don't hesitate to increase your first estimate. If something can go wrong, it will so have backup plans ready.

• Will the materials require special treatment which could increase the cost? Examples include flame retarding, preserving the colors of any materials affected by light, and maintenance costs through the years.

• Are there fees payable to a broker, agent, or subcontractor? Are there extra costs for installation?

• Have you accounted for any costs to produce detailed designs, samples, models or first attempts/drafts?

• Does your agreement include a provision for unseen problems that were not apparent when you first made a quote on the job? You should add such a paragraph that protects you from hidden costs like structural supports, reinforcement parts, labor and equipment, extra travel time and expenses should you have to return to the installation site afterward.

• Include a fee to add to your quoted price which allows for customers who change their mind. That is, the buyer switches choices on a color or material after you have quoted on a project. Also, there may be times when you might have to substitute materials because you can no longer get a particular ingredient.

• Include a clause in your agreements allowing a percentage of increase should specified materials be unavailable due to factors you cannot control. If you don't have such an agreement, you could lose money.

See the sample budget proposal in the following section on submitting a request for quote when bidding on a project.

When you do commission work, you may want to break down your labor into categories for the sake of billing purposes. For instance, you spend so many hours designing a project, so much time laying out the pieces, more time installing and additional hours adding the finishing touches. This will help you in future estimations.

Sample Request for Quote

Most large communities and some states have *Art in Public Places* programs. These projects become available to artists from time to time, depending on the community's funding resources and other factors. If you can handle creating large one-of-a-kind constructions and installation, these venues provide an amazing amount of public exposure to your work.

When applying to *Art in Public Places* projects that require detailed proposals, you can find sample forms to imitate online, like at http://www.clevelandpublicart.org/assets/sample_budget. pdf or the samples in this PDF for artists applying to public art projects: http://www.box.com/shared/static/b282znaflu.pdf

Below is a list of costs to account for taken from a sample budget submitted with an application for a public arts program. It covers expenses you may encounter.

- Artist's fee includes time spent on research, travel, planning, meetings, idea development, model making, fabrication and installation.
- Contract labor for hiring assistants and other labor to complete project, structural engineer, electrician or plumber, architect, historian, attorney, photographer, model maker.

• Travel by air or car plus hotels and meals.
• Freight costs for shipping of materials to your studio and then to installation site.
• Materials and supplies.
• Preparing site of installation and should include site survey.
• Equipment needed for installation like forklifts, scaffolds, truck rental, building permits.
• Studio overhead includes your rent, phone, and utilities.
• Insurance from loss, fire, flooding, theft, damages during shipping, workman's compensation, general liability, and transportation riders.
• Contingency amount of 10% to 20% for cost overruns.

Points to remember:
• Learn what other artists charge for similar one-of-a-kind pieces
• As your brand grows, so can your prices
• Gallery owners can help you determine a price
• Be sure to account for broker's fees in your prices
• Pricing by the square foot may be easier than adding all your costs
• Pricing commission work requires taking into account a myriad of detailed costs like in the sample request for quote above.

How do you keep track of all the data that eventually leads you to arrive at your best prices and increase your sales? Perhaps one of the most important habits of successful business owners is good recordkeeping, covered in the next chapter.

Chapter 6
Recordkeeping

"If your outgo exceeds your income, then your upkeep will be your downfall." ~ Bill Earle

There is one aspect of being self-employed which seems to be universally dreaded—recordkeeping. Perhaps this is because it reminds us of homework assignments we were given in school. Keeping up with your business records is like homework. Only the grade may be more important now than it was then. The grade is whether you have enough money to pay your bills and feed your family.

Getting to the right price is important. If you do your bookkeeping homework and follow the guidelines in this book, you can be confident you will arrive at prices for your products that make you a profit. This chapter teaches you which parts of your business to keep track of and how to analyze these records so you can make intelligent decisions about what to do from day to day and into the future.

One of the perks for having your own business is that you can deduct legitimate business related expenses, covered more in Chapter 10. The IRS requires businesses to maintain accurate records of their expenses and their income. Having and using a recordkeeping system will provide evidence that you are in fact in business and not just attempting to deduct the costs of doing your hobby from your income.

Start Keeping Records

Start keeping records from the day you plan to do business, whether you are selling anything yet or not. If you are passionate about making and selling things, you are probably already taking notes when ideas occur to you. Part of those notes should include a projection of what all your costs will be and where your sales will come from.

Open a separate checking account for your business. It's easy to confuse business with personal transactions when they are both present in your personal checking account. When tax time rolls around, you'll be grateful for the separate business checking account where all your deductible expenses can be easily accessed. Once you've started selling, deposit your income from sales into your business checking account.

In addition to checks you write for business costs, you will also have receipts for deductible expenses paid for with a credit card or cash. The simplest, fastest and least troublesome way to organize these records is to collect all business related receipts and keep them in folders named by expense category. For example, receipts for business calls go into a folder named *Phone* and receipts for what you pay out to travel to a craft show go into a folder named *Travel*. Depending on your business model, you may have more folders named to keep track of: *Rent, Insurance, Licenses, Training, Supplies, Employees* and *Automobile*. I like to name my folders the same way that the IRS categorizes expenses as it makes it easier come tax time and for handing over to an accountant. The IRS list of business expenses is in their Publication 535 (see http://www.irs.gov/publications/p535/index.html .)

The important point is to have a system in which you can quickly locate records of your business expenses. You can then

find and compile the numbers you need to file your income tax as well as make any financial projections for the future.

Bookkeeping by Hand vs. Software

Keeping records can be done by hand in a bookkeeping journal or by entering information into an accounting software package. If you are just beginning and unsure of whether you will stay in business, you may find it simpler to keep records on paper. General recordkeeping journals are plentiful on Amazon and at stores like Staples and OfficeDepot. An example is *Dome's Weekly Bookkeeping Record* by Nicholas Picchione, CPA. If you don't already have one, you may also want to get a filing box or filing cabinet to separate and store all your records in folders like mentioned above.

A paper recordkeeping system will work okay until you reach a point when increased sales take too much time to record entries by hand. At this point, using software becomes more cost effective. You will know that time is near when you find yourself spending more hours than you can afford to spend looking up records, writing invoices, or trying to do a cash flow projection or profit and loss statement to file quarterly income tax estimates or the year end filing.

There are many software programs to help small business owners manage their records. Most are sophisticated enough to give you in-depth reports on all aspects of your business in seconds. *QuickBooks* by Intuit is recommended by the Small Business Administration. Depending on how at ease you are with software, *QuickBooks* may be a good choice. The program allows you to generate many kinds of reports quickly and track sales by item or any other kind of classification such as color or size.

QuickBooks will also let you enter a customer's name, address, and other information and fills it in for you automatically when you begin typing the first few letters, which saves time when producing an invoice or statement. You can also export your mailing list when you want to send out postcards or other promotions to your customers.

For popular alternatives to *QuickBooks*, see: http://www. techrepublic.com/blog/five-apps/five-alternatives-to-quick-books-for-business-accounting/1160

When to Use a CPA

Should you hire an accountant or CPA? For most, the expense of hiring an outside bookkeeper or accountant can only be justified when the business becomes so large that the owner can't handle it alone any longer. As your sales, income and expenses grow, having someone else take care of the record-keeping becomes more and more attractive. In the early days of your business, though, you may not want the added expense.

Whether you do your own bookkeeping or retain an accountant to maintain your books throughout the year, when it's tax time, you may come out ahead by paying a CPA for end of the year tax filings. They can often find legitimate deductions you may have missed as well as being up to date on changes in the tax laws.

Learn Basic Accounting

You don't need a degree in accounting, but you should have basic bookkeeping skills. *Small Time Operator, How to Start Your Own Business, Keep Your Books, Pay Taxes & Stay Out of Trouble!* by Bernard Kamoroff, may be one of the best guides for learning how to keep records in ways that satisfy

the IRS. Kamoroff is a Certified Public Accountant who wrote the book originally for craft business owners and it covers the important topics, including: permits and licenses, insurance, financing, leases, business plans, bookkeeping, taxes, employees, partnerships, corporations, trademarks, dealing with the IRS, and much more.

Many Small Business Development Centers or SBDCs offer basic accounting courses for small business owners. I mention SBDCs a couple of times in this book because they are an excellent and often free or low-cost way to get advice, training and sometimes even coaching in your business. Find an office near you at http://www.asbdc-us.org/About_Us/SBDCs.html. Bean Counter is a free course at: http://www.dwmbeancounter.com.

Additional Records to Track

There are some types of business expenses you may need to keep logs for, including recording mileage when you use your automobile for business. The IRS will allow you to write off so much per mile for business use of your car and ask if you have proof; a mileage log acts like a diary and helps you document your miles. Some software programs like *QuickBooks* include a way for you to enter your mileage and print it out as a report.

It's handy to have a log of other business travel related expenses like meals and entertainment costs. The IRS has a couple of ways of letting you deduct meals and entertainment. One way is by taking a standard per diem (per day) deduction for meals based on the city you are traveling to while doing business. Since you are allowed to deduct a percentage of business related meals, save and record all your receipts. Add up the totals and compare with the per diem rate to discover which gets you a bigger deduction.

Some of your assets, like tools and equipment, purchased for business use are expenses that may have be deducted over time. In tax terms, this is known as depreciation. A portion of the cost of the assets is deductible over several years until the entire costs are accounted for. See Chapter 10 for more about the tax advantages.

There are different types of assets and the IRS assigns different periods for their depreciation. The tax laws for depreciation change frequently. If you have large expenditures on fixed assets, like expensive tools and equipment, the safe path to follow is to use a CPA. In preparation, keep the following:

• Receipt with date purchased or brought into use.
• Description of equipment or asset.
• Method of depreciation (see your accountant.)
• How much of the asset such as a vehicle is used for business or personal.
• Original cost of the asset.

Recording and organizing your sales and expenses serves more than the tax man. It allows you to zero in on which products you make earn money and learn if others are costing too much to continue producing. The next chapter helps you analyze those numbers you have been keeping track of and answer the question, "am I making a profit?"

Chapter 7
Are You Making a Profit?

"Make every thought, every fact, that comes into your mind pay you a profit. Think of things not as they are but as they might be. Don't merely dream—but create!" ~ Robert Collier

Keeping track of income and expenses lets you analyze your product sales and markets to learn their strengths and weaknesses. Without the insight that comes from accounting, you could be selling lots of stuff and losing money. This chapter shows you how to produce financial reports for your craft business that keep you aware, informed and up-to-date.

Financial reports tell you your break-even point. They give you an overview of your business's monetary health. They tell you if each of the products you make is profitable. Generate these reports regularly and you will see exactly where action is needed at any given moment. You'll also be able to use these reports to chart a course for the future.

All of the reports mentioned in this chapter use the data discussed in the last chapter. If you are just starting your business and don't have existing records to use, you'll have to guess about sales and expenses. After about six months to a year, you'll have real numbers to work with.

Breaking Even

Break even is when your overhead equals your revenues. For instance, say you are a stained glass artist and your average

piece sells to stores for $50 and your monthly costs of doing business average $900. Below is a way to determine the number of items you need to sell to meet your expenses given those figures. "Y" is the number of units you need to sell.

$$\$50 \times Y = \$900$$
$$\$50Y = \$900$$
$$Y = \$900 / \$50$$
$$Y = 18$$

You must sell 18 pieces a month to cover your overhead costs and stay in business. However, this formula does not tell you if the piece you are selling at $50 is priced profitably.

Item Profitability

Determining an item's profitability helps you decide whether you can afford to sell wholesale to stores, catalogs, or through a sales rep. Until you know exactly what your item's costs are, there is the risk that you lose money since most wholesalers will pay you only 50 percent of their retail price.

The following chart shows how much profit you make on an item based on cost of sales per market. Create a chart like this for every product you make. In the table, production cost equals the sum of materials, labor, and indirect costs that we looked at in Chapter 4.

Profit by Market: Handmade Bird House				
Market	Price	Cost to Make	Cost of Sales	Profit
Online Stores	$32.00	$12.00	$1.32	$18.68
Craft Shows	$35.00	$12.00	$15.00	$8.00
Home Parties	$35.00	$12.00	$2.00	$11.00
Interior Designers	$22.00	$12.00	$7.00	$3.00
Reps to Stores	$22.50	$12.00	$16.00	($4.50)
Catalogs	$24.50	$12.00	$12.00	$0.50

By looking at the profit left from sales in each of the above markets, we see right away that selling at online stores followed by home parties and then by craft shows yields the most profit per piece. This tells us we should list in more online stores, do more home parties and craft shows. Selling to stores via reps is losing money, so the wise thing is to stop using reps or find ways to lower your production costs.

If you only sell a few different items in only one or two markets, you may know in your head what to do more or less of. But even if you think you know, do the numbers and check it out to be certain. When I did this with my business, I uncovered an overlooked market that was more profitable than the others and quickly put more attention there.

Now, look at the numbers over a year's sales. Take the number of units sold for each market over a year and multiply this times the amount of profit. This gives you an overview of where your strongest markets and profits are coming from. Like-wise, it will tell you what markets to pull out of. For example, look at the following table for the number of bird houses sold in several markets over a year's time.

Profit by Market for Year: Handmade Bird House			
Market	Units Sold	Profit	Total Sales
Online Stores	60	$18.68	$1,120.80
Craft Shows	133	$8.00	$1,064.00
Home Parties	21	$11.00	$231.00
Interior Designers	3	$3.00	$9.00
Reps to Stores	50	($4.50)	($225.00)
Catalogs	670	$0.50	$335.00

We see more volume and profit from selling online than any other market, even though sales at home shows were fairly profitable per sale.

Another element to consider when you are evaluating different markets for how you want to grow your business is ease of sales. Selling to catalogs like the Sundance Catalog, for instance, only requires one presentation, i.e. to the catalog buyer. The catalog buyer then orders from you as sales come in and their inventory goes down. By looking at our chart above, we see there was lower volume from the catalog sales, but craft shows took a lot of energy and time to work. Home shows had a high margin of profit and they were fun to do.

Use a chart like the one above to make a projection to see what would happen if the retail price of the large bird house could be raised to $40 from $35 (you would have to test to make sure you didn't lose sales at the higher price.) Such an increase would bring an extra $665 profit at the end of the year.

Detailed Examples of Cost of Sales

1. Selling jewelry at craft shows. Let's say you sold jewelry through 23 art and craft shows last year. Also, you spent an average of 30 hours per show, including driving, setup, the hours of the show, tearing down, and driving home. Total hours spent to sell your pieces through these shows for the year were 690.

For this example, you have sold a total of 2,000 pieces. Divide 690 hours by the number of items, or 2,000, to get an average time of .35 hours, or approximately twenty minutes selling time per piece.

OF HOURS SELLING = 690
DIVIDED BY # OF ITEMS SOLD = 2,000
GIVES YOU HOURS TO SELL ONE ITEM = .35 HOUR OR 20 MINUTES

The hourly rate you have decided to pay yourself is $10 an hour and the hourly rate of your fixed costs is $8.03.

HOURLY LABOR = $10.00
HOURLY FIXED COSTS = $8.03
TOTAL COSTS PER HOUR = $18.03
$18.03 PER HOUR TIMES .35 PER HOUR TO MAKE ONE ITEM
EQUALS COST OF SALES FOR ONE ITEM OF $6.31

Your cost of sales selling your jewelry to stores in this example is $6.31 per item.

2. Selling jewelry wholesale to stores. Suppose you sell your jewelry to stores and you sold 3,000 pieces to shops or galleries in one year. You spent twenty hours a month getting and servicing these accounts. You also spent $575 in producing and mailing catalogs to store owners. Here's how you would figure cost of sales:

20 HOURS x 12 MONTHS = 240 HOURS
240 HOURS x $18.03 HOURLY COST = $4,327.20
PRODUCING AND MAILING CATALOGS = $575.00
TOTAL COSTS OF SELLING = $4,902.20
$4902.20 DIVIDED BY 3,000 PIECES = $1.64 EACH

Your cost of sales selling your jewelry to stores in this example is $1.64 per item.

In determining your cost of sales, it doesn't matter so much that you might be selling 20 differently priced items. You probably spend the same amount of time on average selling a $20 set of earrings as you do selling a $100 necklace. What is important is that by looking at cost of sales, you can learn if each item and each market is profitable.

After learning about all the costs we have talked about in these last two chapters, you may wonder how anyone is able to charge enough to fully recover their expenses while producing craftwork. Many crafters don't recover their costs and they don't

stay in business very long either. To avoid being one of them:

- Increase the perceived value of your pieces so you can charge prices that bring you profits. See Chapter 2.
- Lower your material costs. See Chapter 8.
- Streamline your production. See Chapter 9.

If you want to succeed in your craft (or any other kind of) business, develop the habit of keeping records of all expenses and sales on a regular basis. If you are working your business part-time, it should only take a couple of hours a month to stay current. If you are a full-time working craftperson, it may take an hour or two every week. Whatever time it takes you, the effort will pay big dividends.

Creating Financial Reports

Financial reports quickly tell you the monetary health of your business. Most accounting software programs take only a few moments to generate reports showing your income and expenses in detail or in summary.

Financial reports can also be used:

- To determine a correct price for all your products
- When figuring your taxes
- In writing a business plan
- When applying for a loan
- When you need to know the status of your business
- When identifying strengths and weaknesses
- When preparing to sell a business
- When taking on investors' capital.

Think of your accounting reports like x-rays. And like a doctor, you can examine these x-rays to see how the patient, your

business, is doing. There are three insightful financial statements that are virtually must haves.

- Cash Flow Projection
- Balance Sheet
- Profit or Loss Statement

Cash Flow Projection

Ever wanted to peek into the future? For your business, a Cash Flow Projection may be the next best thing. It's a forecast of how money comes into and flows out of your business. You use it as a projected budget to tell you when you are most likely to need more cash for operating expenses.

Money comes in from sales of your craftwork, teaching classes, selling excess materials, loans, and whatever additional income streams your business creates. This money is used to run the business, pay off loans and interest, and for your personal salary. For instance, if you need $25,000 a year to operate the business plus a salary for yourself of $25,000, you will need to generate $50,000 of total income just to stay even.

The benefit of the Cash Flow Projection is that you can project forward in time how much money you will have and when you will need it. Without that insight, your business can be profitable and still fail because of lack of cash on hand when bills are due. What happens frequently in a craft business is you take the money you have on hand and invest it in materials or show rental fees, usually months in advance of actual show dates. Now you no longer have that money to pay for more immediate expenses like rent or phone. The endless catch-22 is that you must continue to invest in materials and reserve selling places in order to carry on the activities that will bring in income.

A Cash Flow Projection helps you plan ahead for sources

of cash to allow you to keep operating until sales are coming in. You can build a simple Cash Flow Projection by listing all the cash flowing out of your business and all the cash flowing in for a specific period, usually the coming year.

Cash going out includes:

- Business licenses, permits, and promotional material
- Direct expenses like labor and material costs
- Indirect expenses like rent, utilities, phone, etc
- Assets or long-term purchases like equipment
- Debts or liabilities, that is, payments on loans
- Your salary and other expenses.

Cash coming in includes:

- Beginning cash on hand in cash or bank accounts
- Income from sales
- Other income like interest or dividends
- Sale of assets like property, equipment, tools
- Loans from banks, friends, or credit cards
- Personal investment, that is, putting in money from your personal assets to keep the business going.

In the past, I found myself falling behind with bookkeeping. I am embarrassed to admit that I once even went six months without looking at my cash flow. After everything was finally entered, I generated reports like those explained in this chapter that showed my income, cost of goods, gross profit, expenses, and profit or loss. The reports showed that contrary to what I had imagined during this time period, I actually made much less profit. I knew I had to quickly start looking for ways to cut my expenses and boost sales. If I had kept up the bookkeeping with more discipline, I could have avoided the unnecessary extra pressure.

The importance of a monthly Cash Flow Projection cannot be underestimated. Using your previous year's records and a little guesswork, you can project forward for the coming twelve months to learn when you will experience a cash crunch or a possible cash surplus.

Below is a sample of a Cash Flow Projection (sometimes called a Pro-Forma Income Statement.) With a Cash Flow Projection, you can see where money is coming from and where it's going to. It tells you when all of this is going to take place. If you use a computer accounting program like *QuickBooks,* this is one of many reports that can be generated automatically *and very quickly.* The program adds all the previous records you specify and then projects the trends of cash out and cash in forward for the period you choose.

Cash In	Jan	Feb	Mar	April	May	June
Sales	1500	1200	2300	2400	3700	3200
Misc income	100	100	100	100	100	100
Total Cash In	1600	1300	2400	2500	3800	3300
Cash Out						
Rent	600	600	600	600	600	600
Phone	49	49	49	49	49	49
Internet access	48	48	48	48	48	48
Liability insurance	60	60	60	60	60	60
Materials	250	325	300	300	450	375
Gas	600	600	600	600	600	600
Food	240	240	240	240	240	240
Bank Fees	12	12	12	12	12	12
Travel		80	150	200	250	240
Listing Fees	15	20	18	22	30	34
Office	50	50	50	50	50	50
Misc.	100	100	100	100	100	100
Total Cash Out	2024	2184	2227	2281	2489	2408
CASH FLOW	Jan	Feb	Mar	April	May	June
Cash on hand	1,100	1,000	1,000	1,000	1,000	1,000
Cash out	2024	2184	2227	2281	2489	2408
Cash in	1600	1300	2400	2500	3800	3300
Cash at end of month	676	116	1173	1219	2311	1892
Overflow	-424	-884	173	219	1311	892

I used Excel to create the cash flow above. Excel allows you to insert formulas that automatically update when you

change or add numbers. This makes it super easy to create a picture of how lowering or raising your prices will affect your cash on hand and end of the year profits. For instance, if you are thinking of raising a product's price from $10 to $12, multiply the number of units you sold last year times $2. Then make a new Cash Flow Statement, this time adding the number of units sold times the increase in price to your income line. This will show you how raising the price will affect your cash on hand.

If your Cash Flow Projection warns you of future cash flow problems, here are some ways of improving Cash In:

- Sell in markets where cash comes to you direct from sales. Examples: craft shows, Etsy, eBay, home parties.
- Contact customers who have bought from you before and offer some kind of special. Previous customers are your most approachable and easiest to reach market.
- Do less wholesale business where stores often take 30, 60, or 90 days to pay.
- Require at least 50% down on special orders with balance due in thirty days.
- Accept credit cards. When deposited to your account, you usually get credit and use of funds within 48 hours.
- Buy supplies and services on thirty days terms. Make this an immediate goal whenever engaging a new service or purchasing from a new supplier.
- Sell what you have on hand first, worry about producing more later.
- Run special offers to reduce slow moving and closeout inventory.
- Avoid using your personal credit cards to finance your business unless you commit to paying the bill in thirty days. What may appear as a quick fix to a cash

flow problem can quickly become an unconscious habit of putting off payments. Soon you find that interest charges have accumulated and some of your cash has to go toward credit card finance charges.

Profit and Loss Statement

A Profit and Loss Statement shows specific business activities over a given period. It is sometimes called an Income Statement because it shows where your income is coming from and how you spent money for that time period. Such a report lets you see areas of greatest expense and which of your sales activities generate the most income.

Much of the information used in generating the Cash Flow Statement can also be used for creating a Profit and Loss Statement. Profit and Loss tells you where you've been while Cash Flow tells you where you're headed.

Creating Profit and Loss and other financial reports described in this chapter is very easy if you use accounting software. Once you have installed your program and set up your business account, update the software with your costs and sales to generate reports that provide an overview of your business.

Notice in the example following how expenses compare to income. Look closely at each expense category. Were all these costs really necessary? Could travel or other expenses be reduced? Can you find other ways to communicate with customers that won't run up your phone bill, like using Skype, email or instant messaging? Financial reports guide you to making informed decisions about what to do to reduce expenses. If your sales are over $2,000 a month, you should probably generate the Profit and Loss Statement at least once every three months to learn where you stand.

PROFIT & LOSS INCOME STATEMENT			
INCOME			
	Catalog Sales	$3,567.00	
	Craft Show Sales	$24,762.00	
	Store Sales	$1,705.00	
	Home Party Sales	$5,409.00	
	TOTAL INCOME		$35,443.00
	Cost of Goods Sold		($8,777.00)
	GROSS PROFIT		$26,666.00
EXPENSES			
	Ads	$1,525.00	
	Auto	$2,768.70	
	Bank charges	$195.67	
	Equipment	$365.86	
	Freight	$567.80	
	Interest	$41.02	
	Miscellaneous	$325.61	
	Office supplies	$234.17	
	Publications	$55.66	
	Phone	$953.55	
	Rent	$3,524.00	
	Travel	$987.50	
	Utilities	$1,349.94	
	TOTAL EXPENSES		$12,894.48
NET INCOME (before taxes)			$13,771.52

If you aren't using software that generates financial reports or you want to create them yourself, there are many free template forms like Cash Flow and Profit/Loss with instructions on how to use them online at http://www.score.org/resources/

business-plans-financial-statements-template-gallery. SCORE is an organization of retired business executives who lend their wisdom to new entrepreneurs.

Points to remember:
- Learn your break even point
- Determine if each item is profitable
- Know your cost of sales
- Create a Cash Flow Projection at least once a month and a Profit and Loss Statement every three months

If you analyzed your business using the guidelines in this chapter, you have a good idea of whether your business is making a profit. If you discover that your profit margins are slim to none, the following chapter gives you ways to cut costs when buying supplies.

Chapter 8
How To Slash Material Costs

"A man with a surplus can control circumstances, but a man without a surplus is controlled by them, and often has no opportunity to exercise judgment." ~ *Harvey S. Firestone*

The prices you ask for your items must bring in enough money to pay you back for the cost of the materials that go into making your products. Reducing your material costs will help you earn more profit from each piece. Though you may imagine your supply costs are pretty well fixed, you can almost always find a cheaper source. It takes a little time and research, but if you are a professional craft artisan, you already know the value of saving even a dime on supplies you use every day. This chapter gives you a head start on where to begin saving today through:
- Getting supplies for little or nothing
- Buying supplies on eBay
- Buying supplies from manufacturers
- Buying from China and other countries
- Finding more places to check for bargains
- Turning your extra supplies into a second income
- Learning how many supplies to have on hand.

Getting Supplies for Little or Nothing
Some crafters incorporate materials found freely in nature like interesting looking tree branches, sea shells, sand dollars, flowers, herbs, stones and crystals. These are often referred to as

found objects. In my store, we get a lot of interest from shoppers browsing our recycled art or pieces made from *found objects*. The only cost is the labor and time involved to gather them.

Other sources of cheap supplies include: garage sales, flea markets, junkyards, construction sites and homes undergoing remodeling. One man's trash is another's treasure. Making craft items from recycled material—junk that's being thrown away— is not only low cost to you, the finished pieces make excellent promotional copy for your hang tags and interesting stories to include in news releases and on your website. Anything you can do to lessen the impact we have on the environment will gain you good will and free press.

Buying Supplies on eBay

Almost every day, eBay shows new listings of wholesale craft supplies. Go to the "Crafts" category and then "Wholesale Lots." Or search for "quilting supplies" or "knitting yarns" or whatever you need for your specific craft materials. For my woven products, I have found yarns for less than half the prices I would have paid full retail prices for at a yarn store.

Buying Supplies from Manufacturers

When orders, sales, and production start increasing on a predictable basis, you can save money by buying your materials in bulk. Locate manufacturers of craft supplies through the Thomas Register; it lists most major manufacturers by product type. Check you library or see: http://thomasnet.com.

Wholesale suppliers sometimes advertise in publications related to your craft or in the craft show guide magazines. Note that most manufacturers require a resale number and may only sell to you if they think you are a dealer or a store.

Contact manufacturers as if you were already in business as a retail store. Many wholesalers will be satisfied with seeing your sales tax ID, business stationery, business cards, and the names of a couple of other major suppliers you buy from. However, some might ask for photos of your 'store front.' Don't be discouraged if a big supplier turns you down. Just keep trying until you've managed to open accounts with any suppliers who will give you thirty days terms (net 30) to pay your bills.

If your business alone does not generate enough sales to justify buying supplies in large quantities from wholesalers, join together with friends or friendly competitors in a similar position to make a big purchase. See if fellow crafters or guild members can help make up the remainder of the order. Networking this way helps everyone.

> *"A bar of iron costs $5, made into horseshoes its worth is $12, made into needles its worth is $3500, made into balance springs for watches, its worth is $300,000. Your own value is determined also by what you are able to make of yourself."*
> *~ Source Unknown*

Buying From China and Other Countries

Depending on the craft supplies you need, you may be able to find cheap sources in China and other countries. Although your unit cost per item may be lower when buying supplies from China, note that you will also be paying overseas shipping costs, customs fees and custom broker fees. Here are two sites that act as clearing houses for manufacturers of craft supplies in other countries: http://www.ffcrafts.com and http://www.alibaba.com. FFcrafts.com is specifically for craft supplies while Alibaba.com lists manufacturers from all industries.

More Places to Check for Bargains

Other ways to find bargain craft supplies include:

• http://craigslist.org

• Forum posts and classified ads on online communities and social networks related to your craft

• Ads in newsletters of local craft guilds

• Wholesale craft supply company listings at http://www.wholesalecentral.com/Crafts-Supplies.html

• Sales at Hobby Lobby, Michaels and Joanns

• Newspaper ads for craft supply stores going out of business

• Goodwill and other thrift stores

• Google the phrase "wholesale craft supplies" substituting your media for craft. For instance, bead artists search for "wholesale bead supplies." I listed this method last, because there are many websites purporting to sell wholesale to the public, though most just use the terminology as a marketing ploy. But I have found a couple of legitimate wholesale suppliers after sorting through the other kinds of listings.

Turning Your Extra Supplies into a Second Income

When you start buying supplies in large lots, you may find yourself with more than you need. I bought yarns direct from mills I located through the Thomas Register, but had to buy in large quantities. I turned my wholesale buying into a mail order retail supply business and went through all the steps to appear as a legitimate retail outlet. This opened many doors for me with wholesalers. I was also able to buy directly from other factories who would have otherwise not sold to me.

You can sell your excess supplies to beginning crafters or other customers like I did. Some crafters have found so much business coming their way, they have opted for running the supply business full-time. Personally, I was more interested in weaving, so I just kept it going to get my supplies cheaper.

After a few initial prepaid purchases, most suppliers will grant you thirty days terms to pay otherwise known as 'ordering on account' or 'net 30.' This helps you because you have an extra month's use of cash from sales before paying for supplies.

How Many Supplies to Have on Hand

A problem for the beginning professional crafter is that they are often cash strapped and can only afford to spend enough to produce items they feel certain they can sell quickly. Almost every new business owner faces the dilemma of how much of their precious cash to spend on materials and inventory and how much to reserve for marketing.

In the first couple of years of selling my handwoven pieces, I put much of my profit from sales back into buying more yarns to work with. In fact, I put back too much, until I started selling my extra supplies to other weavers.

Start with enough raw materials to produce the number of finished pieces you think you will sell in the first six months. Thereafter, every time you sell a piece from your inventory of finished goods, put aside the amount of material costs in a separate checking account just for purchases of supplies. This method allows you to recover your investment in supplies and not get seduced into buying more materials than you are selling. If you don't do this, you may end up supporting a shopping habit instead of running a business.

*"No gain is so certain as that which proceeds from
the economical use of what you already have."*
~ Proverb

Many crafters make use of scraps and leftover materials
for constructing smaller pieces. By maximizing your materials
in this way, you can achieve a lower unit cost. For instance, a
weaver might produce several yards of fabric used to construct
garments. The cutouts not used for the garments could be used
to make handbags, earrings, belts, scarves, and so on. A wood-
worker who makes furniture or other big projects can use scraps
for constructing wooden gift boxes or toys.

Just getting more involved in depth with your craft over
time will put you in touch with social networks, publications,
related websites, guilds and fellow artisans who help you iden-
tify ways they save when buying materials. Summing up, we
helped speed the search for saving when buying materials by:

___Getting supplies for little or nothing

___Buying supplies on eBay

___Buying supplies from manufacturers

___Buying from China and other countries

___Finding more places to check for bargains

___Turning your extra supplies into a second income

___Learning how many supplies to have on hand.

Two more elements involved in improving your profitabil-
ity are working hours and working space. Experience over time
will teach you numerous shortcuts. The next chapter gives you
a head start on how to become your business's own efficiency
expert with ways to improve your production.

Chapter 9
Making More Profit from Your Time and Work Space

"One thing you can't recycle is wasted time."
~ *Anonymous*

The bottom line is that your profit equals your income less your expenses. Therefore, it pays you to leverage every effort for maximum results. This chapter gives you time and workspace tips to help you lower your overall costs and boost productivity by increasing the actual amount of work you can get done when and where you work.

How to Manage Your Time & Reduce Labor Costs

Working more hours doesn't always mean you get more done. Working more efficiently in the time you allot for your craft business allows you to accomplish more tasks with fewer efforts. Here are some solutions to help you start using your time more effectively.

PROBLEM: Many of us use little post-it notes to jot down reminders of what we need to do. After writing the note we stick it on the wall or leave it on a pile on our desk or table. The problem is that we often forget to act on the notes, let them pile up in disarray, and tend to ignore them altogether or they get lost in the pile. Eventually the undone tasks we originally wanted to remember accumulate and production slows down. We spend additional time just trying to locate the half remembered notes.

SOLUTION: Take down all those notes from the wall and the ones lying in a pile on your worktable. Get a legal pad and write down every task and reminder, one after the other. This is your "THINGS TO DO" list. Once you have everything on one list, you are now in a position to stay on top of, to act on tasks, and to follow up. Write everything down on the list. The more projects and to-do items you put on your list, the more in charge of your time you'll be. As you accomplish a task, cross it off your list. What's left at the end of the day goes on the next day's list which you fill in at the end of each day.

PROBLEM: You are so creative that you can't stop making new pieces. But now you can't keep track of everything and people are ordering stuff from your Etsy store that you haven't made in awhile.

SOLUTION: Create a project log for every item you make. List the size and weight, materials, costs, the time it takes to produce and any special instructions. Include a drawing or better, an image of the piece. You might find it easier to not make so many different items and focus in on a manageable number of pieces that you know sell.

PROBLEM: You have so many things to do, you don't know which task to do first.

SOLUTION: Set aside a little time to plan your work for the coming day or week. Schedule the morning hours for your most important jobs. Many artists report that early morning is their most creative time. Set aside routine tasks like recordkeeping or paying bills for the end of the day. This may seem simple in

theory, but most of us find it's too easy to become distracted by reading the mail or talking on the phone. Meanwhile our money making projects get pushed aside. Avoid taking the time to finish the easy tasks first just to get them done and out of the way. If you do this, you won't have the energy or time to do those really important projects.

PROBLEM: The THINGS TO DO list is fine for daily tasks, but how do you keep up with what you need to do four months from now?

SOLUTION: Use a daily planner or an online tool like a Google calendar to keep track of coming show application deadlines, show dates, phone appointments and meetings. You can track everything on calendar pages or by priorities and schedule future TO DO projects. Most planners also have an address book built in to record important contact information. Another advantage is that a daily planner provides a diary of your work flow. Should you ever be audited by the IRS, a task diary is usually acceptable evidence you are engaged in a business rather than a hobby.

PROBLEM: There are too many names, too many online listings and offline shows, too many deadlines and too many changes to keep writing down in a calendar. And next year, you have to start again.

SOLUTION: Use a contact manager program or an accounting program with contact management built in. With a contact manager, you can enter thousands of names and other data, and if there are changes, simply go in and retype the information. You can easily add customers, suppliers, and other names and

important information about these folks you want to remember like family members or birthdays. You can add notes on conversations. You can create mailing labels of your customers. Contact managers have a calendar for scheduling upcoming events and reminders that pop up to tell you when you need to act. You can also prioritize your TO DO list and print it out.

Organize Your Workspace to Boost Productivity

A cluttered workspace is psychically and emotionally draining. When you show up to work and find your production table covered with leftover materials, dust and miscellaneous notes, you experience immediate irritation and weariness. Clutter can cause you to misplace needed tools and parts as well as details of special orders and important show dates. You may view piles of unorganized materials as more work than there actually is to be done, thus curbing your enthusiasm and creativity.

Organizing your work space gives you more control over your work time. Employees, if you have them, can find things when you may not be around to direct them. A tidy place to produce your crafts allows an ease of work flow that lowers your cost of labor. Being organized gives you the freedom and ability to shift directions at a moment's notice, should you discover your next great craft product to sell.

> *"Do you know what amazes me more than anything else? The impotence of force to organize anything." ~ Napoleon Bonaparte*

Disorganization is a habit. You can replace this self-defeating habit with simple, easy habits. By applying a little discipline and developing a system, you can reduce your stress

level and increase your profits beginning now. It is much easier to keep everything organized than it is to sort through a mess.

Answering the following questionnaire will help you learn whether your workspace is working for you or costing you:

- Are you set up for production? Can you make better use of your equipment and materials by making more units of a particular item than just doing one or two at a time?

- Is your workspace adequate for your workload?

- Is there enough lighting and ventilation?

- Do you have enough room to move around without constantly avoiding bumping into boxes or tables?

- Have you listed all the steps involved in producing your item and organized your tools, equipment, and material in the order that you will use them?

- Is there enough elbow room around your work table to produce your craftwork with ease?

- What patterns, instructions, and other information must you have easy access to?

- Are your materials organized in a way that you know exactly where to find what you need?

- Do you find tools and equipment, family pictures, magazines and papers crowding the workspace so much that you have no place to work?

- How do you handle unfinished craft projects at the end of the day?

- Do you foresee needing a larger workspace in the near future?

• Will you have to accommodate other workers in the same space?

• How often do you forego production to check email or use the Internet for browsing?

It may be that much of your production work requires spreading out over a work space. This is not clutter. Clutter is when unrelated materials or papers end up mixed together. You can create and maintain an organized work environment by:

• Sort through materials, supplies, magazines, and books that never get used. When is the last time you used these items? Do you need them or just want them? If you haven't used materials in the past two years, consider selling them or throwing them away.

• Draw a diagram of your ideal workplace. Laying out parts on an assembly table puts everything within reaching distance.

• Organize your work space according to tasks. Group like things together. Ganging up pieces with similar components increases the amount of pieces you can make in a given time. Place supplies and tools for particular projects in one place.

• Hang or place tools in designated areas and return tools to their place at the end of a work day. A messy shop or office is an outward sign of an inner state of mind. Are you really in charge or are you simply responding to circumstances?

• Arrange tools and equipment so that you move from

one stage of production to the next with little effort.

• Set up your operation so that you only handle materials once in any given step.

• Create a flow chart on paper of the various steps necessary to produce each item in your line. Examine your chart closely to see that all steps really flow from one to the next with minimum effort.

• If you face a massive reorganization, don't try to do it all in one day. Work methodically, taking enough time to put everything where it serves your work flow best.

• Tackle one work area at a time.

• When organizing becomes tiring, stop and rest.

• If you require additional space for storage or assembly, build or buy a building large enough to accommodate your immediate and future needs.

Some craft artists create their pieces using hand tools as a way of preserving and carrying on a handcrafted tradition. Others make use of power tools and equipment to speed the production process. It's a personal choice, but a tool that reduces your labor by thirty percent will soon pay for itself many times over with increased productivity.

At some point, you will look at upgrading equipment to increase your output. The test is that if sales are rising and it is clear you can only keep up with demand through purchasing needed equipment, then you are probably ready. Look at your records to determine whether your current cash flow will support such a purchase. If your income won't support such a payment, you may have to seek a loan. Fortunately, loans for equipment

and inventory are more easily approved because the physical equipment can be used as collateral.

Purchasing tools and equipment for your business may be tax deductible, as are many other costs you spend to keep the business running. The next chapter explores tax advantages from running a craft business.

Chapter 10
Tax Advantages From Your Craft Business

*"Next to being shot at and missed, nothing is quite
as satisfying as an income tax refund."*
~ F. J. Raymond

Are you in business or are you involved in a hobby? In order to qualify for business deductions you have to prove your activities are based on the objective of making a profit. One of the best ways to document your intentions of making a profit is to keep consistent records of your business as described in previous chapters. You also need to know about expenses you can deduct from your income and lower your tax bill. The tax strategies in this chapter may help you reduce taxes and save money. However, because the tax code changes frequently, it is suggested you consult with an accountant about how current any information here is before making any business decisions. Tax advantages covered in this chapter:
- Overlooked deductible business expenses
- Deducting your start-up costs
- Deducting your home office
- Hiring your children
- Leasing from your children
- Hiring your spouse to write off medical expenses
- Leasing from your spouse
- Deducting business use of your car
- Deducting business travel and entertainment
- Depreciating of tools and equipment

• Avoiding IRS audits
• Dealing with IRS agents

Overlooked Deductible Business Expenses

If you look at the Schedule C form from the IRS for item-izing deductions for your business, the form lists very basic categories like rent, utilities, wages, auto, and so on. There are actually many more deductible expenses than they list, but you have to learn about them elsewhere; the IRS doesn't explain them to you. The IRS criteria for whether a business expense is deductible include:

• Expenses are connected with your business
• Expenses are necessary and typical of your type of business
• Expenses aren't extravagant.

Here's a list of expenses you won't find on the IRS forms that you can probably safely deduct as long as they meet the above conditions:

• Alarm systems
• Business license
• Cell phones used 100% for business
• Child care for your employees
• Cleaning services
• Commissions paid to Etsy, eBay, sales reps or similar
• Consultant's fees
• Copyright registration fees
• Damages to business property
• Decorating your place of business
• Design costs for promotional material
• Domain names for your business

- Exterminator service
- First aid medical supplies
- Greeting cards
- Improvements
- Independent contractors
- Internet access if used only for business
- List rental
- Logo design
- Magazines related to your business
- Moving costs when moving your business
- Packaging supplies
- Plants in the office
- Protective clothing
- Royalties you pay out
- Safe deposit box
- Safety equipment
- Seminars related to your business
- Sewer service
- Shoplifting losses
- Shows and events you display at
- Signs for business
- Stereo system for office, if not extravagant
- Storm losses
- Studio rental
- Tax return preparation
- Temporary help
- Toll road access
- Tools if they are inexpensive
- Trade show tickets
- Warehouse rental
- Web site design and set up

These deductions are from the book, *475 Tax Deductions For Businesses and Self-Employed Individuals* by Bernard Kamoroff, CPA.

Deducting Your Start-Up Costs

When you begin your craft business, you spend money on expenses that the IRS calls "start-up" costs. There are two ways to deduct these costs. One is that you capitalize the costs and get the deduction when you quit or sell your business. Obviously this is a lousy deal because how many crafters will actually sell their business? The other way start-up costs can be deducted is to amortize or spread out the deductions over five years. But you must choose to do this in the start-up year. It is important in the beginning of your business to make the right choice or you could lose your deductions.

For instance, say you spent $7,000 on equipment, tools, furniture, travel, and rent to start-up a craft business which as of yet does not exist. You deduct these expenses from your income as normal business expenses. The IRS disallows your deductions because the business did not exist when you put that money out. By this time, you are into the next tax year. You lose the chance to amortize and must now wait until you sell or quit the business.

To get your deduction, choose to amortize these costs in the tax year during which the active business starts. Consult an accountant. Start-up costs are any money paid to create an active business and any expenses that would normally be deductible if there were an existing business. Examples include travel, entertainment, hiring consultants, advertising, training, finding suppliers, finding buyers, getting professional accounting advice, tools, and so on.

Deducting Use of Your Home Office

You can use many structures for your home office business. Examples include a house, apartment, condo, mobile home, or boat. You can also include structures on property like a separate garage, studio, barn, or greenhouse. The IRS considers your home office as your principal place of business when you:

• Use it for performing the important functions of your business

• Collect money from customers in it

• Spend more time in the home office than at other work locations.

You can deduct expenses for a separate structure like a studio or garage if the building is used exclusively for the business. In this case, the building does not have to be the principal place of business or a place where you meet customers.

You can also expense property or assets used for your business in your home, even if you don't qualify for the home office deduction. For instance, you buy a new work table that costs $500. Your home business does not qualify you for home office deduction because you use the room only 75% for the business (you must use the room 100% for business to qualify.) You can expense $375 of the table or 75% of $500.

You are allowed to deduct up to $17,500 of the cost of new or used office equipment, tools and other qualifying personal property bought in the same tax year. You must use the property 100% for business or you can only deduct the percentage of business use of the property. Also you can only deduct up to the amount of business income for the same tax year. Any cost chosen to be expensed that is above the limitation of the current year can be carried into the next year.

You can deduct indirect expenses like rent, utilities, insurance, security systems, property taxes, deductible mortgage interest, repairs, and depreciation in proportion to your business use of the home. To determine the amount, first find out the total square feet of your home. Then measure the square feet of your home office. Divide the home office footage by the total area of the house. That gives you the percentage to multiply your indirect expenses by.

Say you have a 1,600 square foot house and you use one 400 square foot room for business. You use 25% of your home for business and can deduct 25% of the indirect expenses. Remember to keep a journal or diary proving this room is only used for business. Photos with dates stamped by the film developers will be acceptable evidence.

Hiring Your Children

If your child is over six years old, the IRS says they may be a real employee. If the child is under eighteen years old, wages parents pay their children are a legitimate deduction. You can't use your children as employees if your business is a corporation or a partnership, only if you are a sole proprietorship, independent contractor, or an employee. To qualify the deduction must be:

- A reasonable amount
- Paid for services actually performed
- Actually paid.

Your child's employment must be by the books and you have to prove it with check stubs, receipts, and a diary. Use a time sheet like on the following page to record hours worked and tasks accomplished.

"No matter how bad a child is, he is still good for a tax deduction." ~ Proverb

You benefit from hiring a child under eighteen, because you can deduct wages, which reduces your income and self-employment taxes. However, you have to prove that the amount you pay in wages is a normal wage for the particular tasks and not artificially high.

Leasing From Your Children

Say that you give your daughter equipment like a car you have already completely depreciated and it has a fair market value of $5,000. Your daughter then rents the car to your company for $100 a month for five years.

You get to deduct $1,200 a year from equipment you would normally have gotten zero deduction from because it is already depreciated. Your daughter has to report $1,200 income, but she is probably in a lower income bracket anyway. To meet the conditions for such a lease, you must:
- Give up control of the equipment
- Put the lease in writing
- Make the rental amount reasonable
- Prove you really need the equipment in the business.

Hiring Your Spouse to Write Off Medical Expenses

You can hire your spouse and pay medical expenses under an employee health plan. You can then claim 100% of those expenses as a deductible employee expenses on your Schedule C.

Leasing From Your Spouse

Since rent is a deductible business expense, you pay Social Security and self-employment taxes on your net business income after you deduct any rent you pay to your spouse.

You report rent income (your spouse's) on Schedule E of your tax return where you deduct depreciation. On rental income, you don't pay Social Security of self-employment taxes.

When husband and wife are separate taxpayers, rent paid by the husband to the wife, or vice versa, is deductible by the husband and reportable income for the wife, or vice versa.

Assets you need in your business could be rented from your spouse, including a car, desk, computer, tools, furniture, office equipment, and even office or studio space. The test is do you really need it in your business and would you rent it from a retail rental agent? To pass an audit for claiming the rent from spouse, you must prove that:

- You paid fair market rent for the assets
- You have a written agreement
- Your spouse received payments and deposited them in a separate account
- Your spouse can prove they owned the assets
- You paid state sales tax on the rentals.

Deducting Business Use of Your Car

A trip from your home to your office or any regular place of business is considered commuting, therefore personal, and not deductible as a business expense. However, you can deduct miles driven between two business locations. So if you have a home office and you drive to one of your store accounts, that is legitimate deductible mileage. For 2011 and 2012, the standard mileage deduction was 51 cents per business mile. This rate

changes year to year, so be sure to check the IRS 1040 instruction booklet for the current rate. If you don't use the standard mileage deduction, you can save receipts for all your gas, repairs, tires, oil, insurance, registration fees, and depreciation, but it's easier to take the IRS rate.

You must have adequate records to prove your total miles driven during the tax year. Break down the mileage into business use, commuting, and personal use.

Deducting Business Travel and Entertainment

You can claim travel expenses for your business if you have to spend the night away from home while pursuing business. Even if you spend some time for personal reasons, as long as you spend more days on business than pleasure, you may be able to deduct those travel expenses. For each day of business travel, deduct lodging costs, and 50% of your meals or take a per day allowance deduction as specified by the IRS for the city you are traveling to. If weather or other circumstances prevent you from carrying out your business, you can still deduct the travel expenses.

You can deduct travel costs to attend trade shows, trainings and conventions if business related. If your spouse or children are employed by you, you can deduct their expenses, too.

Your travel expense deductions are more credible if you log and record the expenses at the time of purchase. Usually, taxpayers who lose court cases involving travel lacked proper entries in a diary. You should record:

• Amount you spent on lodging, food, gas, parking, or taxis

• Time of day you departed and returned for each trip and number of days away for business

- Place you traveled to
- Nature of business or purpose of business trip.

Travel related expenses recognized by the IRS include:
- Meals and lodgings, on the way to, while you are at the business destination, and the return trip Transportation costs like air, train, or bus and any fees for baggage, samples, or display materials
- Operation and maintenance costs of automobiles, trailers, or airplanes
- Laundry and cleaning if you dirty your clothes while traveling
- Telephone expenses
- Taxi or bus charges between an airport or station and lodging or place of business plus any tips.

When documenting entertainment expenses, document:
- Who you entertained
- Why you paid for entertainment or what business benefit was expected
- Where the entertainment happened
- When, by date and time
- How much you spent.

"The hardest thing in the world to understand is income tax." ~ Albert Einstein

Depreciating Tools and Equipment

Depreciation means you deduct a certain percentage of the cost each year for the following few years. When you purchase tools or equipment necessary to produce your craft,

the cost of the tools may be deductible in total for that year or if over a specific dollar amount, depreciable over future years (the range changes, so check the IRS guidelines for updates.) Tools, machines, and furniture - like a work table, for example are all assets you will use over time. There are IRS guidelines for different types of assets and how they can be depreciated.

Avoiding IRS Audits

Use a daily planner or appointment book and record your business activities every day. Keep receipts for all expenses and sales, canceled checks, credit card charge slips, letters, photographs, and any additional evidence to support your claims. The way the tax law reads, it is a requirement to keep a diary of daily tasks to prove business activity. In 1995, it became tax law that you are not required to keep receipts for business travel and entertainment expenses less than $75 while out of town.

Try to show a profit. A test if you are in fact running a business and not just doing a hobby is that if you produce a profit in at least three of the last five tax years, the IRS grants that you have the intention of making a profit and therefore you are a business and not a hobby.

As for receipts, keep them all. Canceled checks are not enough alone, as you have to produce documentation to list your expenses.

"The only difference between death and taxes is that death doesn't get worse every time Congress meets." ~ Will Rogers

Use a separate credit card for business costs because you get a receipt as proof of payment and you get a monthly state-

ment as proof of payment. If you make a charge for a business expense near the end of the year, it will be deductible in the year charged. A separate charge card for business also allows you to track finance charges which are deductible.

Some of the documentation proofs that may safeguard you from an audit include an appointment book, a business customer list, a daily log or receipts, journal of expenses and income, deposit slips, bank statements, and canceled checks. Another tip, make sure your receipts match your claims. An auditor can check your motel receipts to show how many people occupied the room.

If your children drive your car, their signature on credit card receipts indicates use by family rather than business. Unless you prove you have them on the payroll doing work for you at the time.

Your auto repair bills will often indicate mileage. Make sure your mileage claims for business use of your car match repair receipts.

Here's additional preparatory advice to help avoid audits:
- Mail your tax return by registered mail, requesting a return receipt
- Mail your return a day before the due date
- Write your registered mail receipt number on your original return before you copy and mail to the IRS
- Add statements, copies of checks, appraisals, police reports, etc. for any casualty claims
- Notify IRS of address change
- File on time
- Have a tax advisor, like a C.P.A., sign your return
- Report all your income
- Don't claim illegitimate deductions

• Don't ever claim more than 14 withholding allowances

• Get a copy of the *IRS Audit Manual* at http://irs.gov and type "audit guide" in the search box there.

IRS Agents

There are two types of IRS employees that will examine your returns. The first is called a tax auditor. A tax auditor is required to have four year college degree in any field, not necessarily accounting. They advance through the ranks by completing basic bookkeeping courses. Tax auditors are not experts in tax law. They look at your receipts, compare them to your returns, and then tell you if you are short. The second type of IRS employee is a revenue agent. They have four year college degrees and a minimum of 24 semester hours of accounting education. The revenue agent is familiar with IRS tax law.

If you are audited, send your CPA or tax advisor to any meeting with IRS agents. They can field any questions on your behalf and deliver explanations to the agent.

The tax tips presented in this chapter give you several ways to cut your tax costs and save you money, like:

___Overlooked deductible business expenses

___Deducting your start-up costs

___Deducting your home office

___Hiring your children

___Leasing from your children

___Hiring your spouse to write off medical expenses

___Leasing from your spouse

___Deducting business use of your car

___Deducting business travel and entertainment

___Depreciating of tools and equipment

___Avoiding IRS audits

___IRS agents

Tax laws change from year to year so consult your CPA before applying any of the suggestions here. A very useful reference for additional money saving strategies is Barbara Brabec's *Schedule C Deductions* at http://www.craftmarketer. com/tax-deductions.htm

Final Note

We covered a lot of ground in this guide but there are some key points to pricing that I hope you put into action right away. Information is pretty useless unless you take action. Get proactive about your business's future by:

- Research the marketplace(s) you will sell in. Learn how others who sell work similar to yours price their pieces.
- Account for all your materials and supplies in terms of what they cost you for each item you produce. If you guess on your cost of materials, guess high to make sure you don't lose money.
- Save and organize your receipts and keep good records so that you can know where your business stands at any moment in time.
- Use a cash flow projection and update it monthly. It's the single most useful tool for looking ahead and for keeping your money in your pocket instead of who knows where.
- Implement the strategies showing how to use pricing to increase sales and you will not only improve your profits, you will find new customers who will come back and buy from you again and again.

To your success,
James Dillehay

About the Author

James Dillehay is a professional craft artist, gallery owner and author of nine books and numerous articles. He has been interviewed in *The Wall Street Journal Online, The Chicago Tribune, Bottom Line Personal, Family Circle, The Crafts Report, Better Homes & Gardens, Working Mothers, Country Almanac*, and many more including Entrepreneur Radio and HGTV's The Carol Duvall Show. He is a co-author of *Guerrilla Marketing on the Front Lines* and *The Best of Guerrilla Marketing*.

James produced a series of webinars for the state of Alaska to help their artists and craft makers market their creative products more profitably. He is passionate about helping others develop fulfilling careers profiting from their creativity. He has presented workshops around the US including events for the National Association of Independent Artists in Atlanta, GA and the Bootcamp Marketing for Artists and Craftspeople in Santa Fe, NM.

James is founder of the social network, Craftsu.com for those who love to buy and sell crafts. He blogs about craft business topics at Craftmarketer.com. He weaves and sells his handwoven wearable art and other pieces at his Treasure Box Gallery in Madrid, New Mexico, near Santa Fe.

Craft Business Books

__Sell Your Crafts Online__ by James Dillehay. Save yourself weeks of research with this roadmap to the best Internet places from which to sell, promote, get reviewed, and find new customers for your handmade crafts. Discover more than 500 Internet promotion ideas including 24 top SEO (Search Engine Optimization) tips to get your web pages free traffic from Google.

Unhappy with your Etsy or eBay sales or just need more outlets? You'll get 85 more places to sell from along with 10 more sites for reaching wholesale buyers, 33 art and craft search directories to list on and get links from, 33 top social and bookmarking sites to grow your network and fans from, 36 places to syndicate your images, blogs, videos, and articles, 16 sites like Cafepress that let you sell your art and designs via on-demand products like t-shirts, mugs, caps and hundreds of other products, and much more.

"James was a guest speaker on our Guerrilla Marketing conference call and he blew me away with what he knows about selling on the Internet," said Jay Conrad Levinson, author of the best-selling Guerrilla Marketing series. ***Sell Your Crafts Online*** is available as a softcover, 6"x9", $12.95 or Kindle edition $4.99. Order from http://www.craftmarketer.com/sell-your-crafts-online.htm

For a free email newsletter with tips and news about craft business, visit www.craftmarketer.com

Promote and sell your crafts free on the social network for craft artisans: www.craftsu.com

Made in the USA
Lexington, KY
24 January 2015